IMAGES
of America

SOMERVILLE

Dear Jason —

Either Somerville will become olishtly more interesting or you'll have this book to help you remember your time here ☺ Happy Hanukah 2019

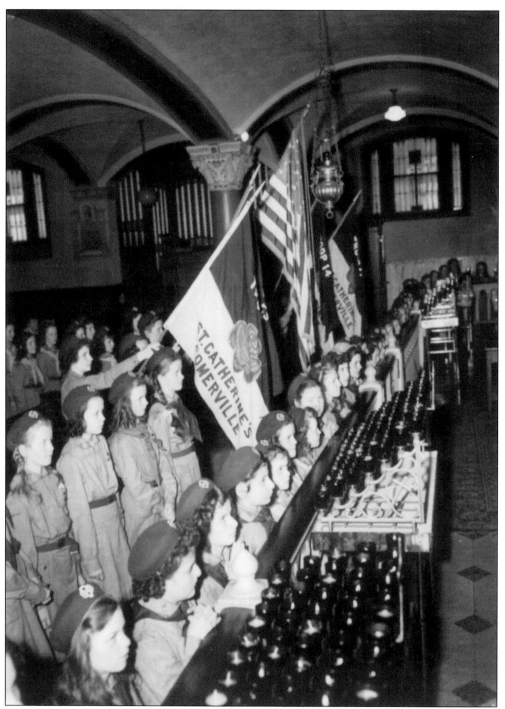

On Girl Scout Sunday in March of 1943, members of the troop attended mass at Saint Catherine of Genoa Church, an Italian Romanesque church designed by Charles D. Maginnis. Kneeling along the altar rail, with older members of the troop holding the American flag and the banner of Saint Catherine's troop, this poignant photograph shows the reverence and maturity of these young ladies. (Courtesy of the Somerville Public Library.)

IMAGES
of America

SOMERVILLE

Anthony Mitchell Sammarco

ARCADIA
PUBLISHING

Published by Arcadia Publishing
Charleston, South Carolina

Printed in the United States of America

Library of Congress Catalog Card Number: Applied for

For all general information contact Arcadia Publishing at:
Telephone 843-853-2070
Fax 843-853-0044
E-mail sales@arcadiapublishing.com
For customer service and orders:
Toll-Free 1-888-313-2665

Visit us on the Internet at www.arcadiapublishing.com

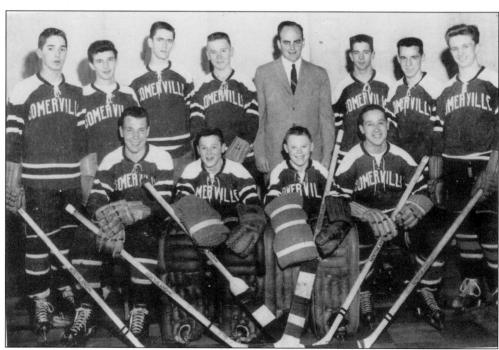

Members of the hockey team of Somerville High School in 1957 included, from left to right, as follows: (front row) Paul Strokes, John Doncaster, Francis Doncaster, and Joseph Zenga; (back row) John Pommet, John Burgess, Phil Ramsay, Robert Quinn, Coach Goggin, Henry Perry, Robert Pennell, and James Burgess. (Courtesy of the Somerville Public Library.)

CONTENTS

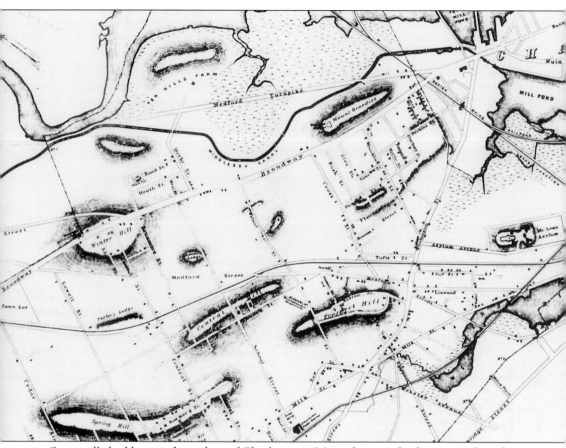

Somerville had been independent of Charlestown, Massachusetts, for five years when this map was drawn by Martin Draper in 1852. Bound on the north by Medford, on the west by Arlington, the south by Cambridge, and the east by Charlestown, Somerville saw tremendous growth after it became an independent town in 1842. (Courtesy of the Somerville Public Library.)

INTRODUCTION

Founded in 1842, Somerville is considered the quintessential "streetcar suburb" of Boston, experiencing tremendous growth in the last three decades of the nineteenth century. Located just 2.5 miles from the Massachusetts State House, its numerous hills and scenic vistas lend it a convenient and picturesque quality, which was a major factor in its popularity as a place of residence in the nineteenth century. Once a part of Charlestown, Massachusetts, Somerville was incorporated as an independent town in 1842 through the urging of Charles E. Gilman, who had prepared a petition that was signed by 152 supporters. Gilman, for whom Gilman Square was named, was to serve as town (later city) clerk of Somerville for forty-six years and to whom is owed the recording of the early history and development of the town.

The original title to the lands now known as the city of Somerville came from Chief Webcowit of the Pawtucket Indians, and his queen, Squaw Sachem. Though little activity was to occur in the first two centuries after Massachusetts Bay Colony was settled in 1630, there was some activity during the Revolution, when the British sailed up the Mystic River to Ten Hills Farm and marched to the Powder House, a solid masonry tower built in 1705 by Jean Mallet near what is now Powder House Square. Led by General Gage, the regulars seized 250 casks of gun powder stored there and transported the casks to Castle William (now Castle Island). This loss dealt a decisive blow to the colonial troops. After the Battle of Bunker Hill on June 17, 1775, the colonial troops, under the supervision of General Putnam, built fortifications on Winter and Prospect Hills, and kept watch on Boston during the siege, which lasted until Evacuation Day, March 17, 1776, when the British soldiers and the Loyalists sailed from Boston. Things were quiet for the next few decades, but by the early nineteenth century the Middlesex Canal was laid out in 1803 from Charlestown to Lowell, along what is now Mystic Avenue, through the support of Governor James Sullivan. This canal allowed freight to be shipped in a swift and convenient manner and spurred the early development of the town. The establishment of the McLean Asylum for the Insane in 1818 in the former Joseph Barrell mansion by the Massachusetts General Hospital Corporation was an important step in the care of mentally disturbed patients, and brought renown to the town. Another important institution was the Ursuline Convent, established in 1826 by the Order of Saint Ursula on Ploughed Hill (or Mount Benedict as it was renamed by the nuns) to educate the daughters of Boston's gentry. An unfortunate anti-Catholic riot took place on August 4, 1834, which led to its destruction, but the ruins of the convent remained on the hill as a grim reminder to those who had destroyed it for decades after the event.

The residents of Charlestown who lived "outside the Neck," or the area north of present-day Sullivan Square, began to demand separation from the town as early as 1828 as the town of Warren, to be named in memory of General Doctor Joseph Warren (1741–1775) who died during the Battle of Bunker Hill. The reasons offered in defense of separation from Charlestown

were the lack of improvements made to their section of the town with their share of the taxes, and the great distance to town schoolhouses and the obvious lack of interest in their welfare. Supported in their desire for independence, it was on March 3, 1842, that the town of Somerville was formally incorporated with Nathan Tufts, John Edgerly, Caleb Leland, Luther Mitchell, and Francis Bowman serving as selectmen, Charles Gilman as treasurer, and Edmund Tufts as collector. Charles Miller suggested the name "Somerville" for the new town saying that "it was a pretty name, and that at that time there was no other Somerville in New England." Within a short period of time, the new town began to flourish and schools, churches, municipal buildings, and new streets were built. It was said that all "the improvements that mark a town's growth to the stature of a city were added as needed," and that in that regard on January 1, 1872, the city of Somerville was the result of nearly three decades of unprecedented growth. The first mayor of Somerville was George O. Brastow, serving from 1872 to 1874. Somerville, with a population of 1,103 at the time of its incorporation as a town in 1842, had a population of 60,000 by the turn of this century, and was truly a thriving city just a stone's throw from Boston.

In the twentieth century, Somerville's population has steadily increased and many of the new residents come from all walks of life, ethic backgrounds, and religious beliefs. With the continued contributions being made by various immigrant groups to the well being of the city of Somerville, we might think of it as a thriving nexus of cultures. In this photographic history of the city, the people, institutions, and churches that have made Somerville what it is are saluted by their descendants.

Somerville! dear Somerville! in history great,
Pregant with tales of thy sons' true valor and worth;
Thou good city of homes, in our own old Bay State,
Where the first flag was unfurled at liberty's birth;
We bless thy clear vision, and all honor thy name,
For most jeleous are we of thy record so fair;
As the years they roll on, not as a speck on thy fame
Can to cheek bring a blush, or thy honor impair.

—James Watters, 1902

One

EARLY SOMERVILLE

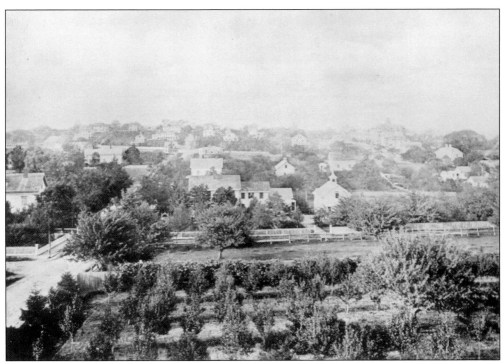

Winter Hill, seen from Central and Hudson Streets, was dotted with small farms and the well-tended orchard of the Dickerman family, as seen in this photograph from 1872. Just one year after Somerville was incorporated as a city, the area of Highland Avenue had become of tremendous value and was shortly to be subdivided for residential development. Winter Hill, which was at the junction of Broadway (often referred to as the Road to Winter Hill, the Road to Newtowne [Cambridge], and Milk Row) and Medford Street, would see large mansions built that enjoyed superb views of Boston, just a couple of miles away.

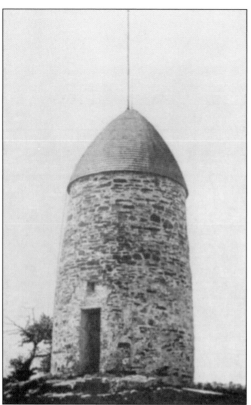

The Old Powder House was built on Quarry Hill, overlooking Two Penny Brook, in 1704 by Jean Mallet, a shipwright and later a miller. Built of locally quarried stone with walls that were two feet thick, it was a gristmill that ground corn into meal. In 1747, the mill was sold for £250 to the province of Massachusetts for a gun powder magazine.

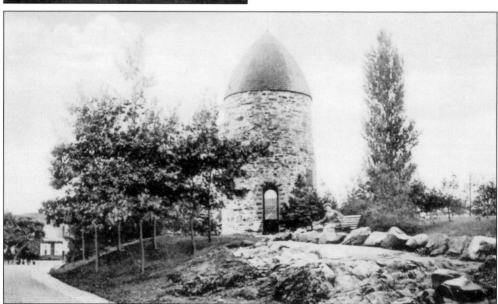

In the late nineteenth century, Nathan Tufts' children presented the powder house and the surrounding farm and orchard to the city of Somerville for a park. The Old Powder House was restored and a park was laid out by City Engineer Horace Eaton and landscaped, being renamed Nathan Tufts Park, and Powder House Terrace was laid out at the same time. A woman sits on a park bench near the old mill turned powder house in 1910.

The Oliver Tufts House was built in 1714 on Sycamore Street and was used as the headquarters of General Charles Lee, who commanded the left wing of General George Washington's army. At the turn of the century, this was the headquarters of the Somerville Historical Society, which was founded in 1897.

The Stearns House was a mid-eighteenth-century house that was built on Broadway between Austin and Union Streets. Located at the foot of Ploughed Hill (later Mount Benedict), it was a typical farmhouse beyond The Neck on the Winter Hill Road.

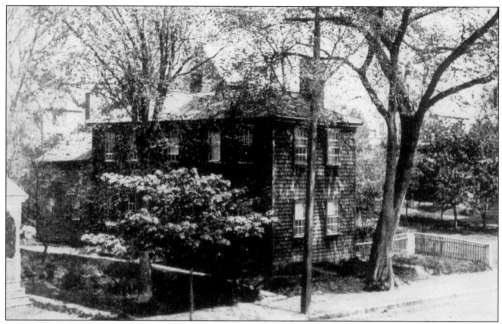

The Hall House was built about 1800 on Elm Street (now College Avenue) and was known as the Swain Strawberry Farm Mansion. The farm was known for its delicious strawberries, which were cultivated on the estate and sold not just locally, but in Quincy Market in Boston. The house was demolished to make way for the West Somerville Branch Library.

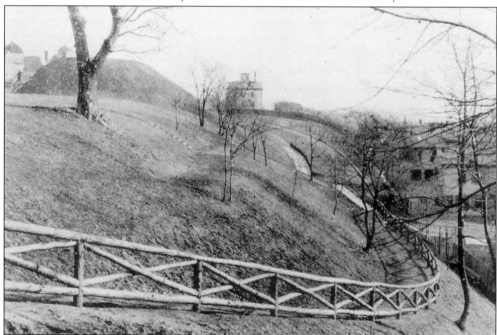

Prospect Hill could almost be considered the rural countryside in the late nineteenth century. After the city decided to fill in Miller's River, which had become a stagnant body of water due to the numerous slaughterhouses, soil was taken from Prospect Hill between 1873 and 1874. Only the center part of the hill was left intact, and it was here that the tower was later built.

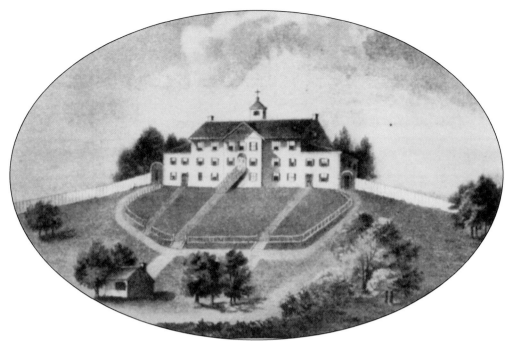

The Ursuline Convent was a magnificent three-story building completed in 1828 on Ploughed Hill, or what was later known as Mount Benedict. The convent was "fully eighty feet long, three stories high, with a large dormer, and a cupola." Here the erudite nuns taught their pupils, ironically the majority of them non-Catholics, everything "which may be found necessary, useful and ornamental in society."

The Adams House stood on Winter Hill on the old "Winter Hill Road," present-day Broadway. Built by Joseph Adams about 1785, it was here the Ursuline nuns took their pupils after they escaped from the convent on August 4, 1834, when it was sacked, and later burned, by the anti-Catholic mob.

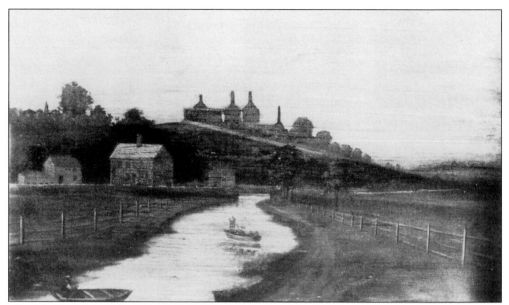

The Middlesex Canal was laid out between Charlestown (later Somerville) and Lowell, with Colonel Loammi Baldwin serving as the engineer for the project. Promoted by Governor James Sullivan, for whom Sullivan Square was named, it was completed in 1803 and reduced travel time to twelve hours from Boston to Lowell. In a painting from the mid-1830s, the ruins of the Ursuline Convent can be seen on Mount Benedict, where they remained for nearly fifty years. Ironically, bricks from the convent survive—as part of the Cathedral of the Holy Cross in Boston's South End.

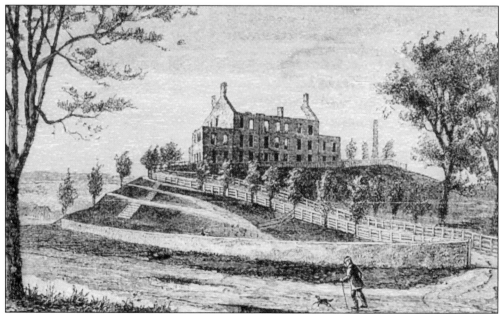

The ruins of the Ursuline Convent still commanded attention as one passed by either on the Middlesex Canal or on Broadway. Set high on Mount Benedict, the remains of the once elaborately terraced gardens remained as did the memory of the unfortunate incident that was brought to mind every time one glanced in that direction.

The Old Oasis was a large Greek Revival house turned general store that was built in the mid-nineteenth century in Union Square near Webster Street. A simple three-bay house with a front porch, it was to witness the great events of Somerville becoming an independent town in 1842 and incorporated as a city in 1872. A group of men stand on the front porch and three horse-drawn carriages are stopped in front. The Old Oasis was also to witness the building of the old Methodist church, whose tower can be seen on the left, just behind the store. On the far right, just past the Robert A. Vinal house (now 15 Union Square), the framing of Saint Joseph's Church is being raised at the corner of Washington Street and Webster Avenue.

Bow Street, which runs on a "bow" from one part of Main Street to another with Dexter Street acting as its arrow, was once lined with simple nineteenth-century houses. By the late nineteenth century, the south side of Bow Street was often referred to as "Doctor's Row" for the large number of physicians who had their offices there.

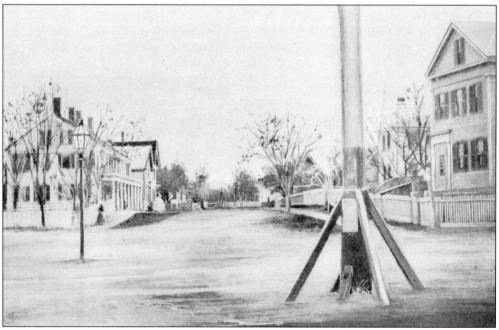

The Old Flagstaff at Union Square flew "Old Glory" during the mid-nineteenth century with a flag that had stars for every state in the Union, and a recruiting office for Union soldiers during the Civil War. Union Square (the junction of Somerville and Mystic Avenues and Medford Street) is Somerville's oldest commercial district, and was often referred to as Liberty Pole Square after the flagpole erected in the square in 1853 by Somerville firemen.

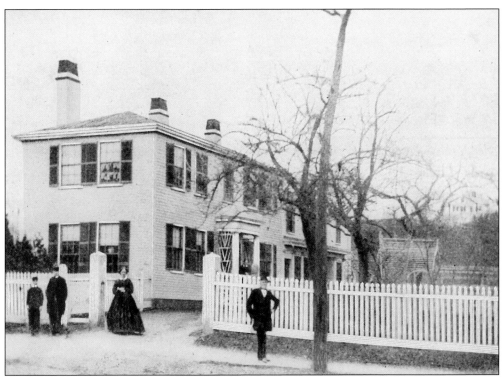

The Robert Vinal House was an elegant Federal house in Union Square at the corner of Warren Avenue. Robert Aldersey Vinal (1821–1867) was, with his partner Edwin Monroe, a grain merchant on Commercial Wharf in Boston. This house was built by his father-in-law and was later the site of the Hotel Warren.

John C. Magoun (1797–1882) was an assessor for the town of Somerville for thirty-four years and served on the school committee as an overseer of the poor. Magoun Square (the junction of Broadway and Medford and Lowell Streets) was named for his family, whose farm was located between Broadway and Vernon Streets.

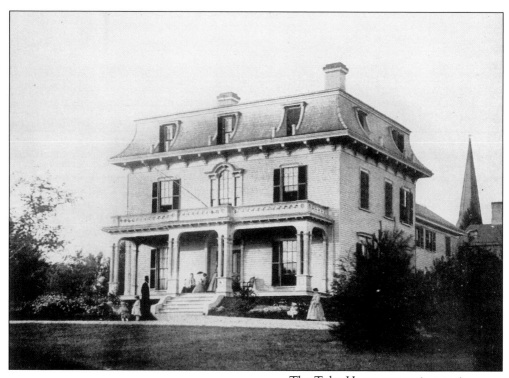

The Tyler House was an impressive Italianate mansion that stood on Central Street. Columbus Tyler was a farmer and steward of the McLean Asylum. Mary Sawyer Tyler, his wife, was the "Mary" in John Roulston's immortal poem *Mary Had a Little Lamb*. The Tyler family poses in front of the house in the 1860s, which later became the parsonage of the Unitarian church and more recently the Somerville Lodge of Elks.

Samuel Teele was the son of Jonathan Teele, for whom Teele Square (the junction of Broadway, Holland, Curtis, and Newbury Streets) was named. A farmer and gardener on his family farm in Somerville, he later sold a portion of his land to Tufts College and in 1868 built a new home on Curtis Street, opposite the reservoir on College Hill.

Charles Williams Jr. was a manufacturer of telegraph instruments at 109 Court Street in Boston. It was in Williams' shop that Alexander Graham Bell and Thomas A. Watson experimented with the telephone, and it was here that they heard the first sound transmitted by such on June 2, 1875. The shop was the location "in which all the Bell telephones were manufactured until the Williams' business was transferred to the Western Electric Company on July 2, 1883." (Courtesy of the Somerville Public Library.)

Charles Williams Jr. lived at the corner of Arlington and Lincoln Streets in Somerville. In 1877, this was *the first residence in the world* to have permanent experimental telephone service, connecting Williams' home with his shop in Boston. Williams had telephone numbers 1 and 2 of the Bell Telephone System. (Courtesy of the Somerville Public Library.)

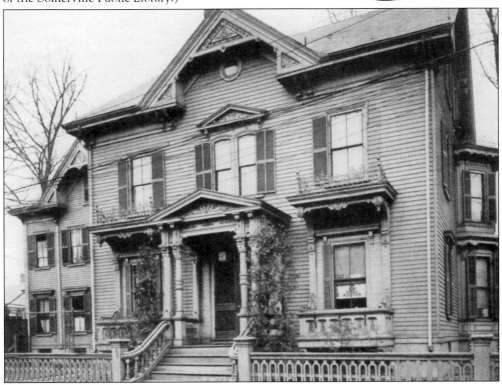

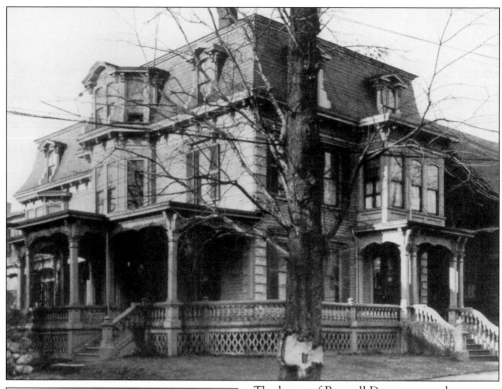

The home of Roswell Downer was a large Italianate house at 170 Central Street in Somerville. In 1877, this house was the first in the world to have commercial telephone service, connecting the Downer home with his office at 28 State Street in Boston. (Courtesy of the Somerville Public Library.)

Roswell C. Downer was the first man in the world to install a commercial telephone in 1877. He worked in partnership with Frank W. Downer (his brother), Joseph Stone, Cutler Downer, and William Monroe as the firm of Stone and Downer, custom house brokers and forwarders. Their office was at 28 State Street and they had telephone numbers 3 and 4, as offered by Bell and Watson. (Courtesy of the Somerville Public Library.)

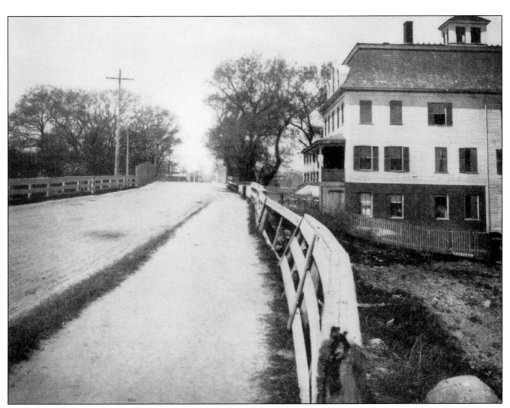

The Old Willow Bridge House was on what is now called Broadway (but was originally known as the Winter Hill Road, the Road to Newtowne [Cambridge], and Milk Row). The area was subdivided for residential development in the mid-1870s, with streets being laid out between Boston, Cedar, Willow, and Morrison Streets. Known as "Somerville Highlands," the Willow Bridge area was served by the Somerville Highlands Station, and was developed primarily due to the ease of travelling for residents.

John N. Ball was a manufacturer of pasted-shoe stock in Somerville. His home was at 690 Broadway, and Ball Square (the junction of Broadway and Boston Avenue) was named in his honor.

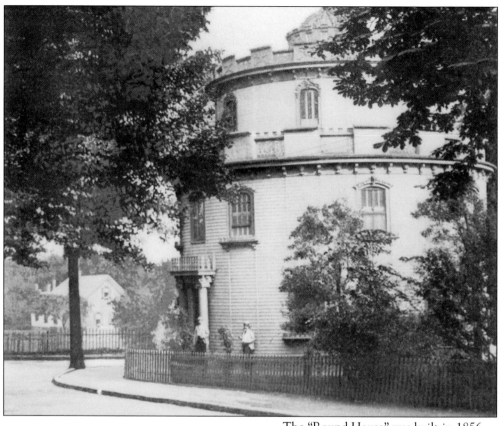

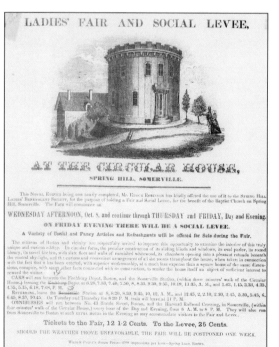

The "Round House" was built in 1856 on Spring Hill (the corner of Pitman and Beech Streets) as the residence of Enoch Robinson (1801–1888), an inventor and locksmith. Octagonal and round houses became all the rage in the mid-nineteenth century and were popularized by Orson Fowler in his book *A House for All, or the Gravel Wall and the Octagon Mode of Building.* The house had crenelated roofs on both levels and circular and oval rooms, with circular paths in the garden, all of which according to Fowler promoted a healthy mental and physical environment.

A Ladies' Fair and Social Levee was held at the "Circular House" on Spring Hill in Somerville. Touted as a "novel residence," the Spring Hill Ladies' Benevolent Society held a fair for the benefit of the Baptist Church in Somerville. (Courtesy of the Somerville Public Library.)

Martha Perry Lowe (1829–1902) was the wife of Reverend Charles Lowe, pastor of the First Congregational (Unitarian) Church from 1859 to 1874. Her "Reminiscences of Somerville" were printed in *Somerville Past and Present* and vividly recall the early years of Somerville, just after it was incorporated as an independent town. A school on Morrison Street was built in 1903 and named in her memory.

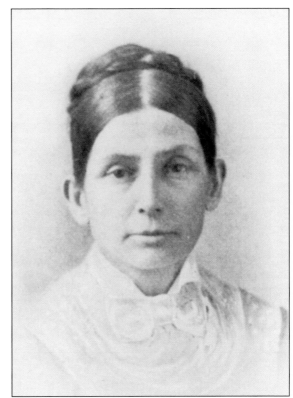

The home of Irvine A. Whitcomb was built at 358 Broadway. An Italianate house with a mansard roof, it was set on well-kept grounds. Notice the carriage house and barn on the left, a necessity before the advent of the "horseless carriage."

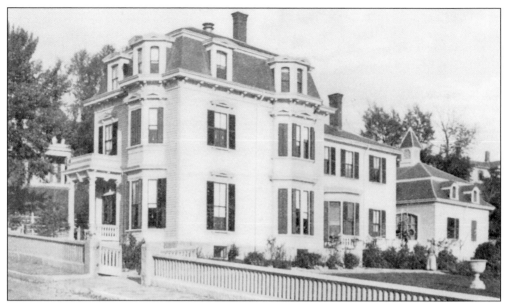

The home of Richard H. Sturtevant was built at 31 Walnut Street. A partner in the firm of Sturtevant & Haley Beef Supply Company, slaughterers and renderers, he served as treasurer and manager of the company.

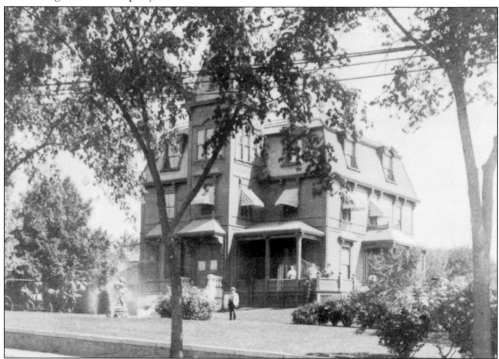

The home of James S. Sanborn was built at 383 Broadway about 1870. A founder in 1878 of the coffee firm of Chase and Sanborn, his "energy and perseverance have been largly the cause of the success that attends all his undertakings." Sanborn's Second Empire-style house had a central tower from which superb views of the Mystic River and the Bunker Hill Monument could be enjoyed.

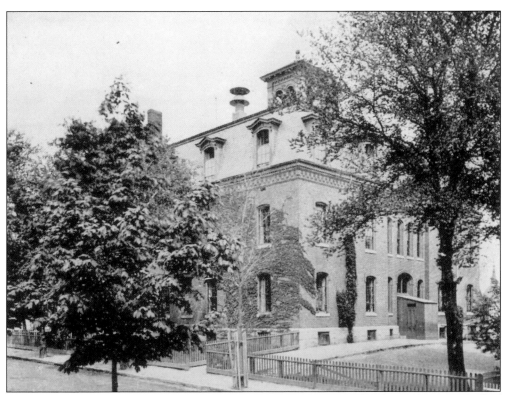

The Forster Schoolhouse on Sycamore Street served as both a school and the town hall of Somerville from 1867 to 1872. The school was named for Charles Forster (1798–1866), who was "always interested in the public welfare" of Somerville, and was built in 1867.

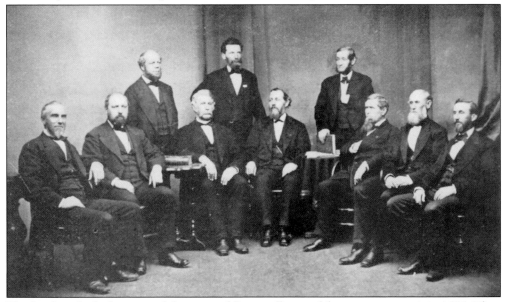

The last board of selectmen of the town of Somerville posed for a group portrait in 1871. They included Cyrus Crosby, Horace Haskins, Person Davis, Jacob Glines, Francis Houghton, Austin Belknap, Charles Gilman, Charles Lincoln, John Hall, and Robert Vinal.

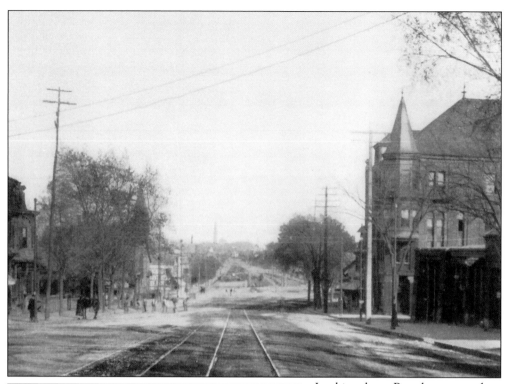

Looking down Broadway toward Boston in 1890, the streetcar tracks lead toward the former "Neck," or what is now Sullivan Square in Charlestown. The Bunker Hill Monument rises in the distance and the city is but a short ride on the streetcar.

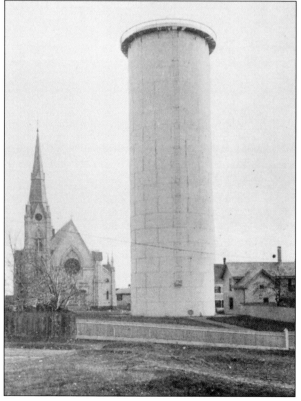

The High Service Standpipe of Somerville was made by Henry R. Worthington and built in 1889 by the city's water department on Belmont Street, Spring Hill. A high-service water system that had a capacity of 528,768 gallons of water, it included a pumping station at Broadway and Cedar Street and served about an eighth of the city's residents. On the left is the First Baptist Church in Somerville.

Two

THE CITY OF SOMERVILLE

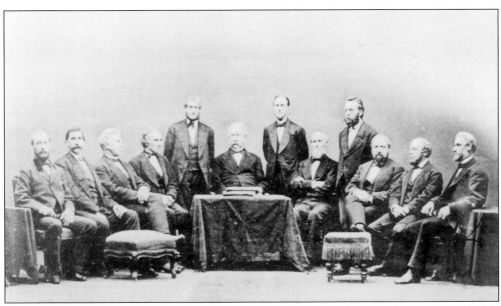

The first board of mayor and aldermen, and officers, of the city of Somerville in 1872 included, from left to right, William Furber, Daniel Chase, Jacob Glines, Clark Bennett, C.E. Gilman, George O. Brastow (the first mayor of Somerville), Aaron Sargent, John Hall, Selwyn Bowman, Horace Haskins, Person Davis, and John Poor.

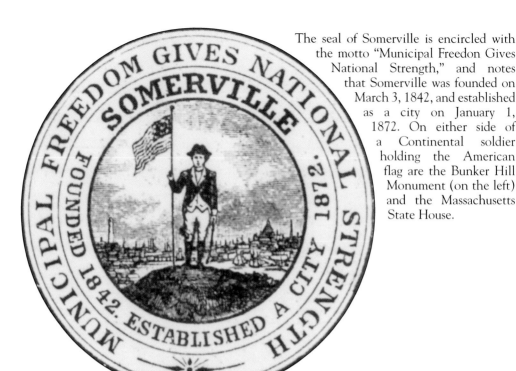

The seal of Somerville is encircled with the motto "Municipal Freedon Gives National Strength," and notes that Somerville was founded on March 3, 1842, and established as a city on January 1, 1872. On either side of a Continental soldier holding the American flag are the Bunker Hill Monument (on the left) and the Massachusetts State House.

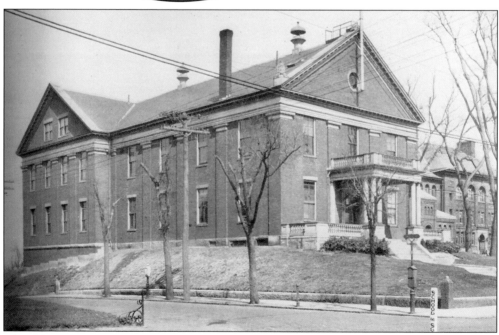

The old Somerville High School was built in 1852. A simple brick Greek Revival school, it was built at the corner of Highland Avenue and School Street, and the first floor was used for town hall. Somerville town offices were eventually moved to the second floor in 1867, and after the Latin School was built the entire building was used for town and then city offices. The English High School, built in 1895, can be seen on the far right.

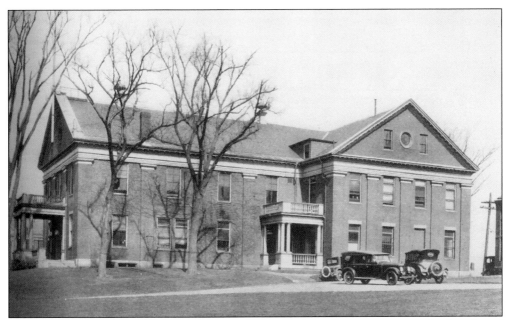

Somerville City Hall had a stately aspect, set high on a knoll on a corner at the far edge of Central Hill, the civic center of Somerville. Notice the brick pilasters between the windows that were maintained with the later additions that were built in 1896 and 1902.

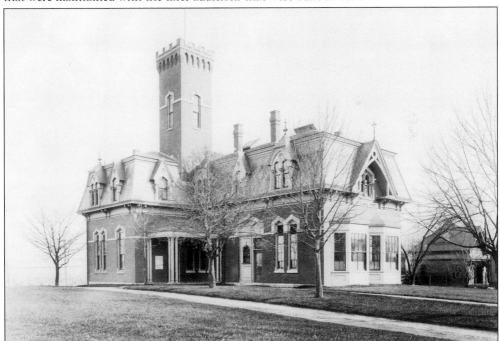

After Somerville became a city in 1872, the space available in the former town hall proved insufficient. This Ruskinian Gothic building with dormers projecting from a slate-sheathed mansard roof was built in 1871 as the Central Fire Station and was used after 1894 as City Hall Annex. Notice how the windows on the right were set in the former doors to the firehouse. (Courtesy of the Somerville Public Library.)

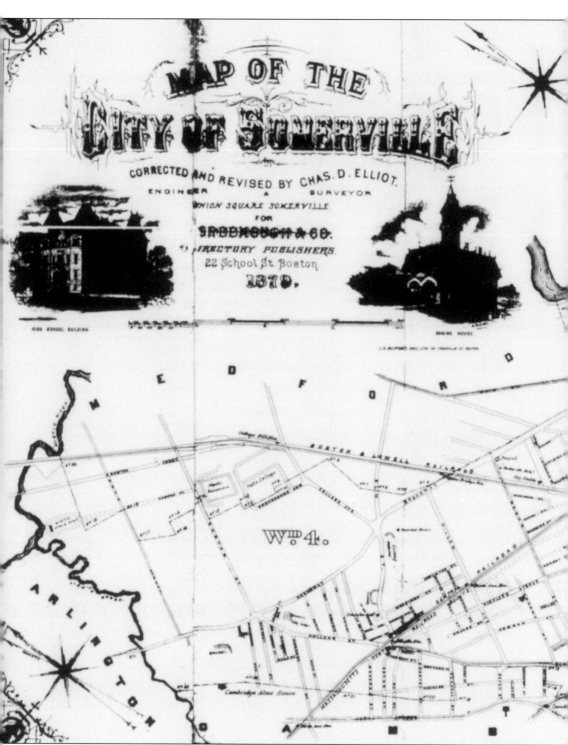

This "Map of the City of Somerville" was drawn in 1879 by Charles D. Elliot, engineer and surveyor in Union Square in Somerville. The left side of the city map had elevations of the high school and the engine house, and the city was divided by wards. Compare Martin Draper's

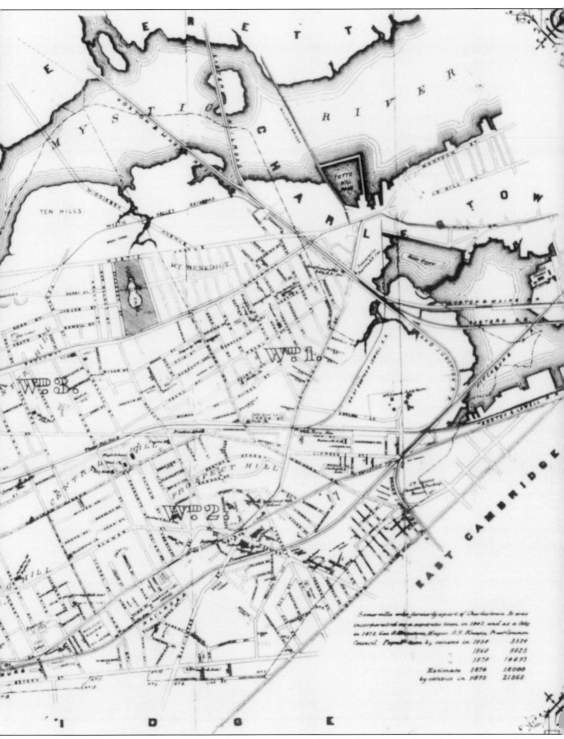

map of 1852 with this map of 1879 and one can instantly see the tremendous development of Somerville. (Courtesy of the Somerville Public Library.)

William H. Hodgkins served as mayor of Somerville from 1892 to 1896. A brevetted major of Company B, 36th Regiment, Massachusetts Volunteers, Hodgkins was author of the *History of the Thirty Sixth Regiment* and *The Battle of Fort Stedman*. In 1892, during his first term as mayor, a gala parade was held celebrating the semi-centennial anniversary of the incorporation of the town of Somerville.

Edward Glines served as mayor of Somerville from 1901 to 1903. During his last term as mayor, the Prospect Hill Park was dedicated. In his inaugural speech in 1902, Glines said of the residents of Somerville that if "'they come and stay here it will be because [Somerville] is healthy, morally clean, comfortable and convenient and because sentiment inclines them to come and stay."

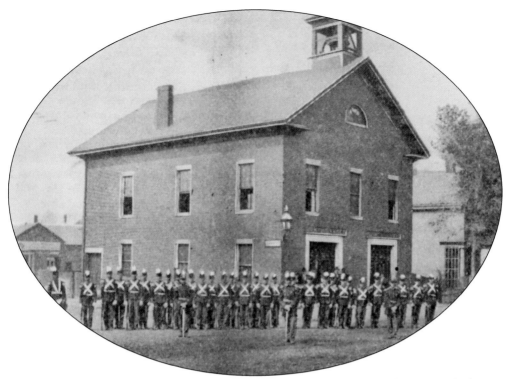

Members of the Somerville Light Infantry line up in formation in 1875 in front of the firehouse. Formed in 1853, the first captain of the Somerville Light Infantry was George O. Brastow, the first mayor of Somerville in 1872. (Courtesy of the Somerville Public Library.)

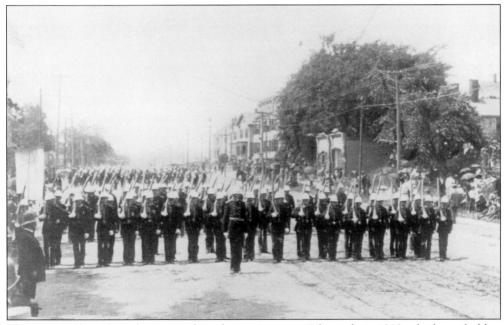

The Somerville Light Infantry march in the semi-centennial parade in 1892, which was held to celebrate the 50th anniversary of Somerville.

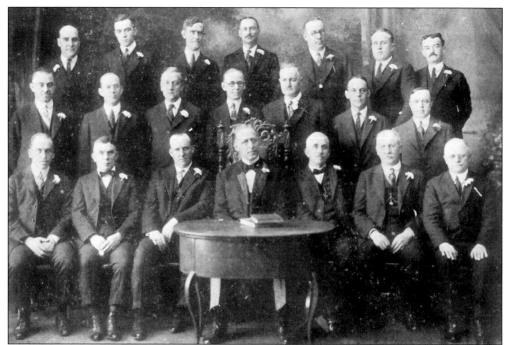

Members of the Somerville Board of Aldermen in 1922 included the following, from left to right: (front row) Lyman Hodgdon, Robert Harris, Waldo Phelps, president Enoch Robertson, Fred Allen, William Abbott, and Hiram Dearborn; (middle row) William Morrison, Francis Smith, Emerson Coldwell, J. Freeman Saville, Thomas Mitchell, John Smith, and William Burns; (back row) John Spiers, Henry Welch, Joseph Haley, Arthur Mason, George Berry, John Hoban, and Albert Hughes. (Courtesy of the Somerville Public Library.)

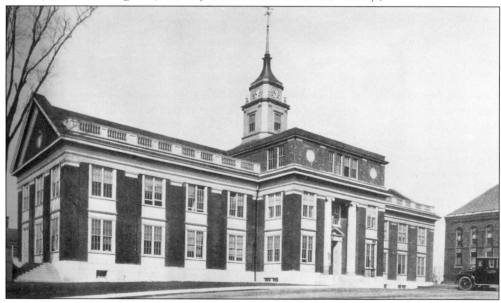

The old city hall was remodeled by Ritchie, Parsons and Taylor between 1923 and 1924 with a new wing on the north and a third story surmounted by a cupola that has a four-sided clock and an impressive weather vane.

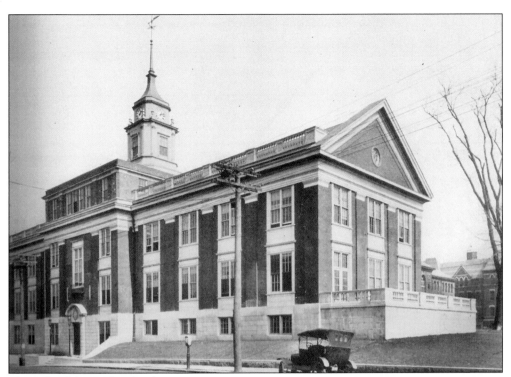

The School Street facade of Somerville City Hall had a new basement level that was cut from the sloping lawns. The classical details such as the roof balustrade and the quoining made for an impressive remodeling of the 1852 schoolhouse turned town hall turned city hall!

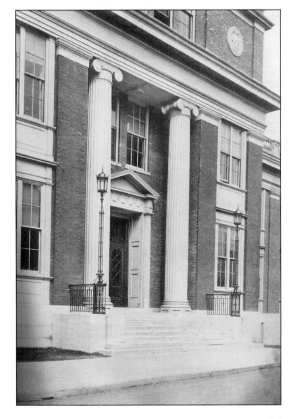

A detail of the main entrance of Somerville City Hall appeared in the June 1926 edition of *The Architectural Forum*. The architects, Ritchie, Parsons and Taylor, had utilized much of the old building, including the brick pilasters between the windows, but added elegant details such as the recessed Ionic columns, the circular medallions, and cast-iron lanterns that flank the entrance.

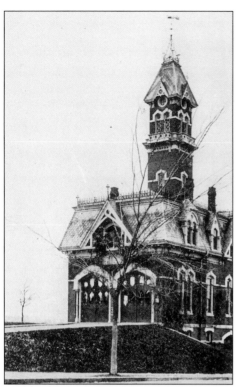

The Central Fire Station was built in 1871 at the corner of Walnut Street and Highland Avenue. An impressive Ruskinian Gothic building, complete with a soaring tower that was capped by a "fire-engine weather vane," this firehouse became Somerville City Hall Annex after 1894 when the new Central Fire Station was built. Demolished in 1913, the present Somerville Public Library stands on its site.

District Chief Young of the Somerville Fire Department stands beside the weather vane from Engine One (Central Fire Station) in 1938. The hammered copper weather vane of a horse-drawn fire engine with two firemen once adorned the Engine House, being placed there in 1871. (Courtesy of the Somerville Public Library.)

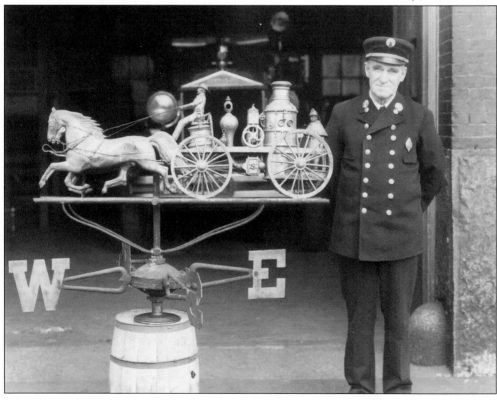

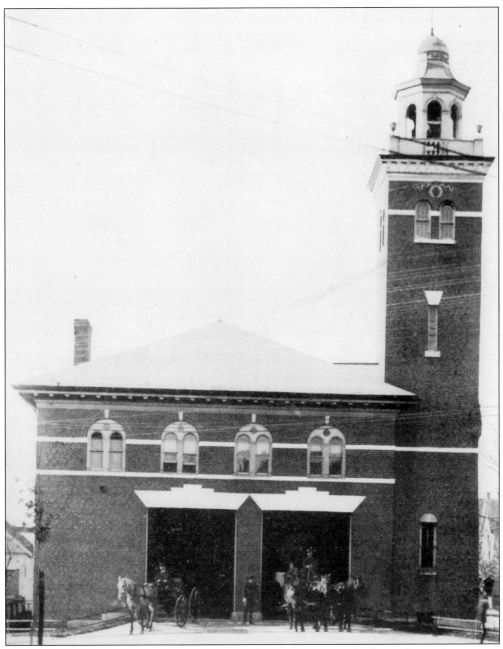

Hose and Chemical Number 6 was built at Teele Square. Notice the horse-drawn fire engines leaving the firehouse. (Courtesy of the Somerville Public Library.)

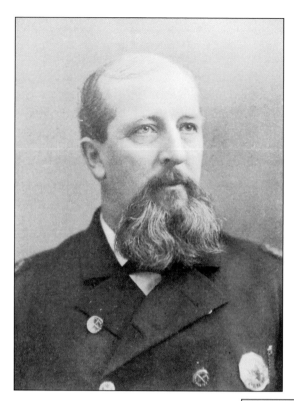

Melville C. Parkhurst was not only chief of police from 1872 to 1908, but the treasurer of the Somerville Police Relief Association at the turn of the century. Organized in 1872, the Relief Association was "dependent on funds almost exclusively upon the annual police ball." This was as good an excuse to have a dance as any other!

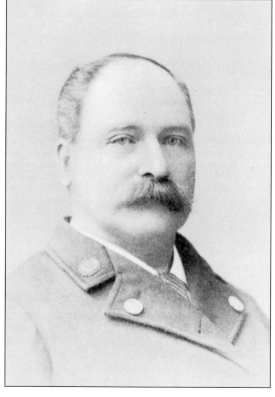

James R. Hopkins was chief of the former Winter Hill Hose Company No. 2 since 1872, which was renamed in 1874 the Robert A. Vinal Hook and Ladder Company No. 1. A modest fireman, he declined the honor of having a new fire engine named for him in recognition of his service to the city.

Sewell M. Rich was chief of the Somerville Fire Department at the turn of the century. An able administrator, he "proved himself well-qualified for the position." A resident of Somerville for many years, he lived at 381 Medford Street.

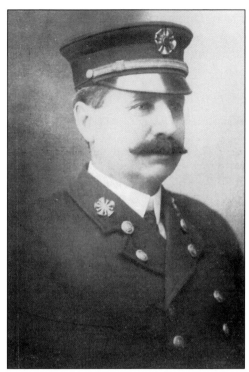

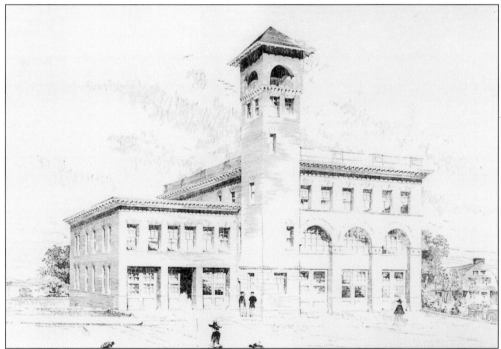

The Central Fire Station of the Somerville Fire Department was designed by Walter T. Littlefield and was built in 1904 at the junction of Medford Street and Highland Avenue. The soaring tower might have been impressive, but its intended purpose was to dry hoses after a fire-call.

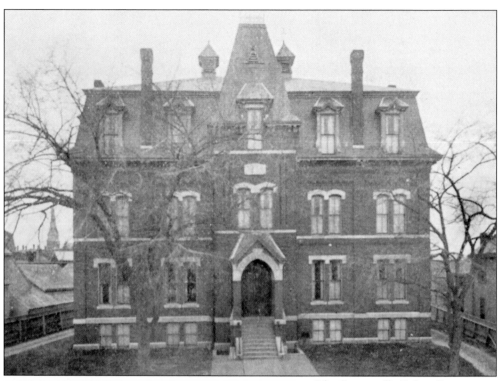

The Somerville Police Station was designed by George H. Clough in 1874 as a brick Ruskinian Gothic building with granite stringcourses and a mansard roof. It was located on Bow Street in Union Square.

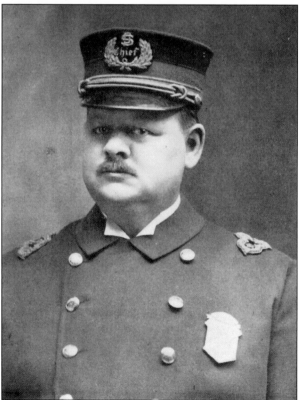

Charles A. Kendall was the chief of police in Somerville at the turn of the century. So efficient was he that his "management of the department has brought it to a commendable state of discipline and efficiency."

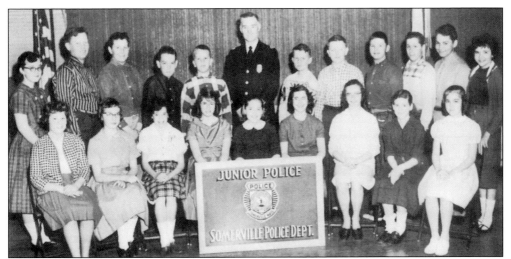

Members of the "Junior Police" of the Somerville Police Department pose for their photograph in 1960. Co-sponsored by the Somerville Lodge of Elks, the purpose of this program was to acquaint the young people with the police department, "its duties, functions, and the important part it plays in community life. The importance of good citizenship is stressed so that each boy and girl will realize that each has a duty to and an important place in community life." (Courtesy of the Somerville Public Library.)

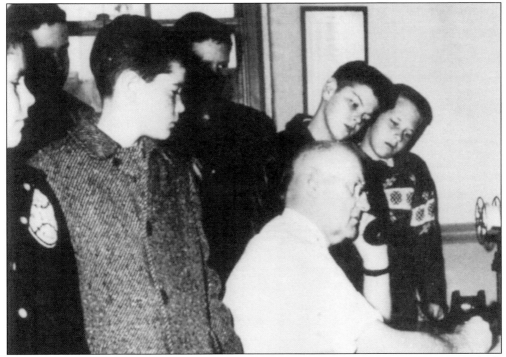

Members of the "Junior Police" had a bus tour of the Somerville Police Department which included everything from being fingerprinted and photographed to a film entitled "The American Cop" that was produced by the March of Time. Here, the future crime fighters of Somerville watch as a policeman takes an important telephone message. (Courtesy of the Somerville Public Library.)

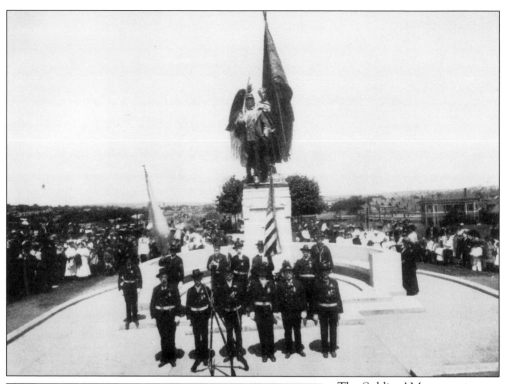

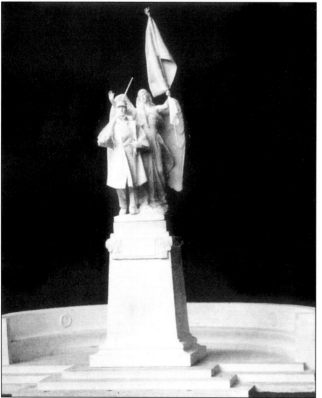

The Soldiers' Monument, erected on Central Hill near the library and high school, was dedicated to those from Somerville who served in the Civil War. Members of the Grand Army of the Republic (Willard C. Kinsley Post 139, G.A.R.) stand in front of the monument on the high school grounds during the dedication.

The Soldiers' Monument was dedicated by the Somerville Light Infantry in 1863 "To the Men of Somerville Who Served the Union on Land and Sea, 1861–1865." The monument, a shaft surmounted by a winged eagle, rests on a plinth base in the Somerville Cemetery and is the first memorial in the country erected in honor of those who lost their lives in the Civil War.

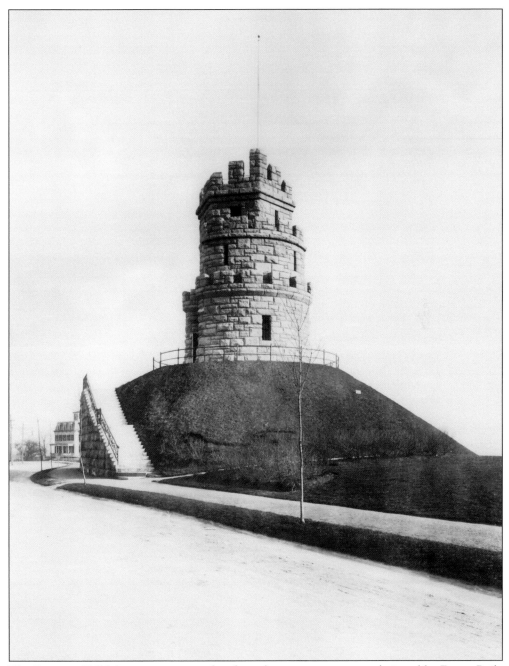

The Prospect Hill Monument, a crenelated rough granite tower, was designed by Ernest Baily and dedicated in 1903. The site was all that remained from the excavations undertaken in the late nineteenth century for fill, and the small hill that remained was created as a park by City Engineer Ernest Baily to commemorate Somerville's role during the American Revolution. (Courtesy of the Somerville Public Library.)

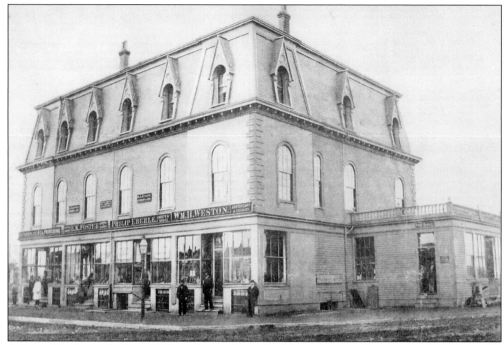

Pythian Block was built in 1872 and was where the Masons met in Somerville. The two-story block had stores on the first floor (from the left were Sturtevant & Company, E.K. Foster, Philip Eberle, and William H. Weston,) and a large masonic hall on the second floor. Notice the Union Square post office on the far right. (Courtesy of the Somerville Public Library.)

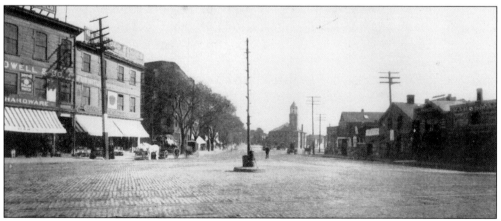

Union Square was named for the union of United States. The junction of Somerville Webster and Stone Avenues and Washington and Bow Streets, it was a far less busy intersection in 1911 when this photograph was taken than it is today. The Central Firehouse can be seen in the distance.

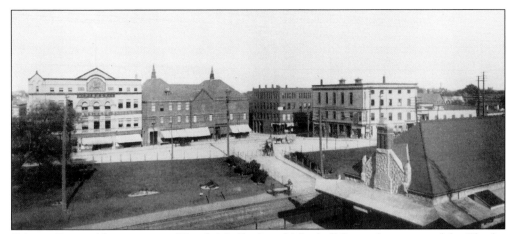

Gilman Square (the junction of Pearl, Medford, and Marshall Streets) was named for Charles E. Gilman (1809–1893), a major land owner in Somerville who served as town and city clerk of Somerville between 1842 and 1886. On the far right is the Winter Hill Station.

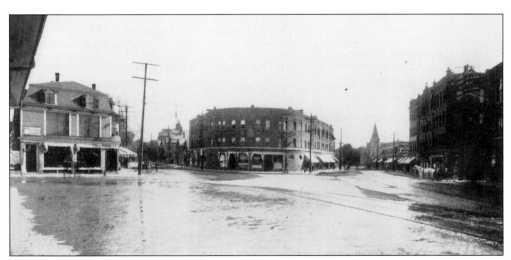

Davis Square, seen in 1912, had College Avenue on the left, Highland Avenue in the center, and Elm Street on the right. The curved building in the center is the Medina Block, built in 1887. The square was named for Person Davis (1819–1894), a grain merchant with Davis and Taylor in Boston, whose estate was at the intersection of Elm, Grove, and Morrison Streets.

The Medina Block in Davis Square was built by John Medina, a native of the Azores Islands who moved to Somerville in 1880 from New Bedford. The Medina Block had stores on the first floor and modern apartments above, and Medina was considered a "pioneer in the improvements of that locality, which followed in the rapid growth of building, population and business generally."

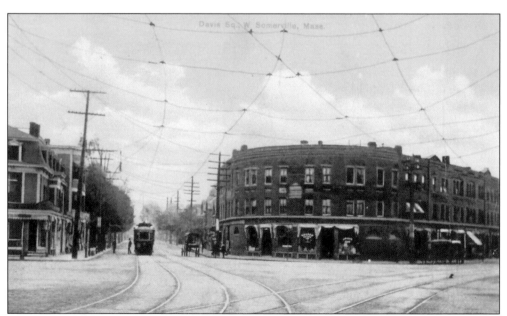

A streetcar approaches Davis Square from Highland Avenue about 1910. Notice not only the numerous streetcar tracks but the abundance of overhead wires. (Courtesy of the Somerville Public Library.)

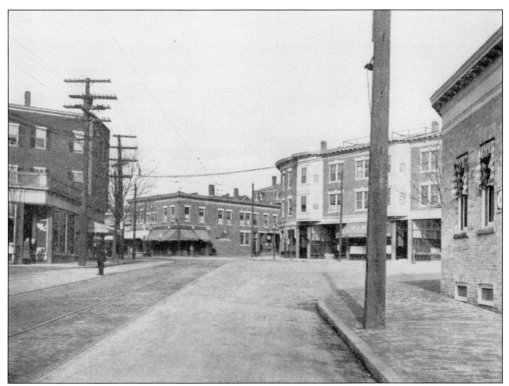

Teele Square was named for Jonathan W. Teele, an early resident of that part of Charlestown that became Somerville in 1842. Teele's grandson, Frank A. Teele, was a prominent real estate dealer, coal dealer, and insurance broker in Somerville, his office being located in Davis Square.

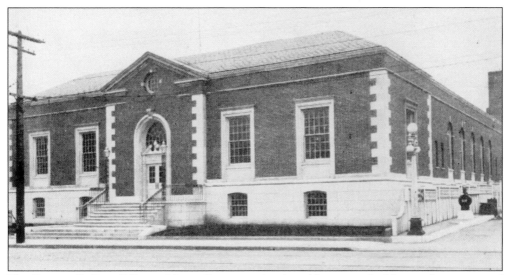

The Somerville Post Office in Union Square is a brick and limestone building with exaggerated corner quoining. The first post office was established in 1846 at the corner of Washington Street and Somerville Avenue. In 1874 Somerville became part of the Boston Postal District.

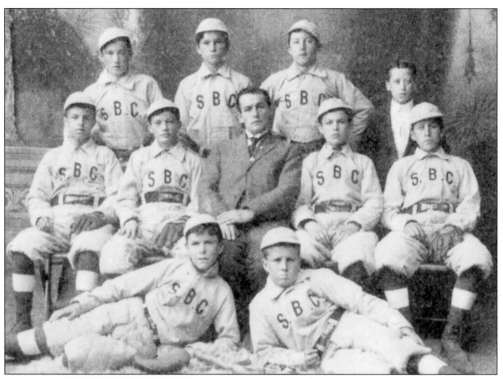

The Camp Baseball Nine of the Somerville Boys' Club pose for a group portrait in 1905. (Courtesy of the Somerville Public Library.)

The old Prospect Hill School House was later remodeled as the Somerville Boys Club, which was founded in 1906 and did at the turn of the century "excellent work among the boys enrolled." (Courtesy of the Somerville Public Library.)

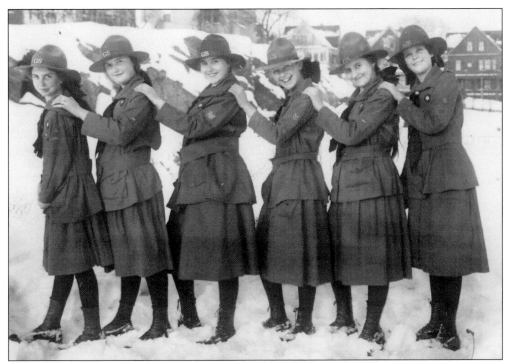

Members of Troop 2, Somerville Girl Scouts, pose for their photograph in 1920. From the left the young ladies are Ethel Hamilton, Priscilla Ripley, Muriel Clark, Gretchen Bowers, Emma Lou Johnson, and Dorothea Boxell. (Courtesy of the Somerville Public Library.)

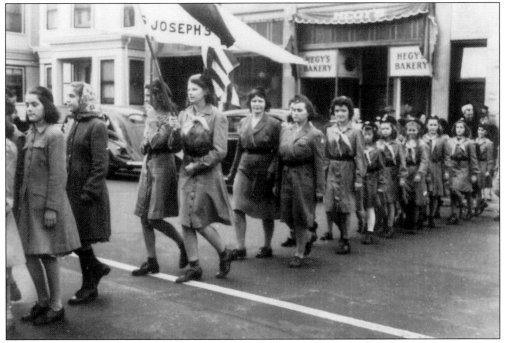

Members of Saint Joseph's Troop of Girl Scouts march in formation (and in descending height) into Mass at Saint Joseph's Church in 1943. (Courtesy of the Somerville Public Library.)

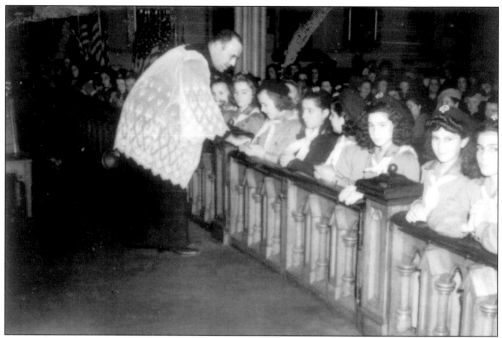

Members of the Girl Scouts receive Holy Communion while kneeling at the altar rail of Saint Joseph's Church. (Courtesy of the Somerville Public Library.)

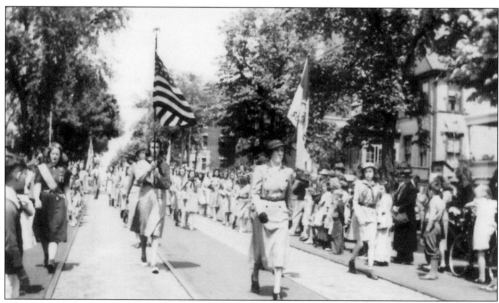

Members of the Somerville Girl Scouts march in the 1941 Memorial Day Parade. Hold those flags high! (Courtesy of the Somerville Public Library.)

The Somerville Young Men's Christian Association (YMCA) was organized in 1867, rendering "a continuous service to youth to the end that a finer citizenry should result and that life might be more worth-while to those who are the 'Citizens of tomorrow.'" The present clubhouse was built in 1905 at 103 Highland Avenue.

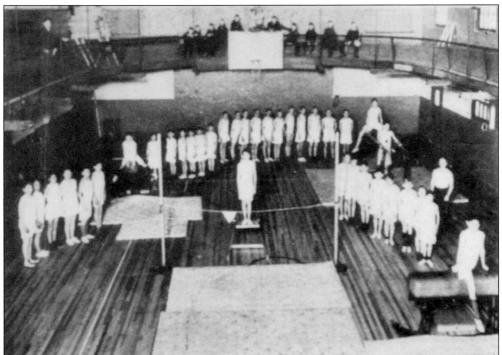

Members of the Gymnasium Class at the Somerville Young Men's Christian Association (YMCA) participated in "wholesome, regular exercise under expert instruction and enjoyed the rewards of abounding health." (Courtesy of the Somerville Public Library.)

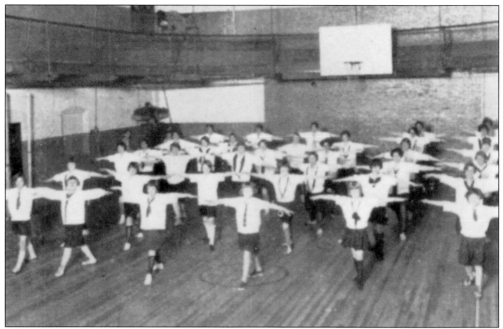

The Girls' Group at the "Y" looked like they were ready for take-off during this exercise class! (Courtesy of the Somerville Public Library.)

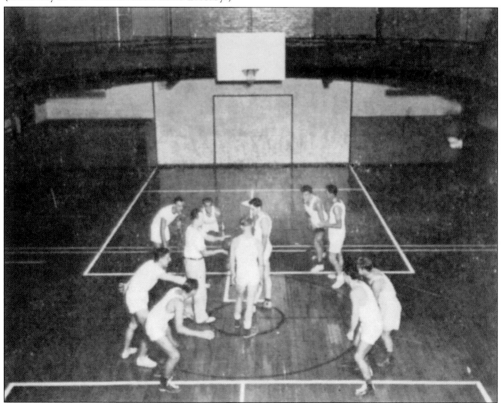

Members of the Somerville "Y" participate in a basketball game in 1941.

A reading room was set aside for the members of the Somerville "Y" for quiet times of study and reflection.

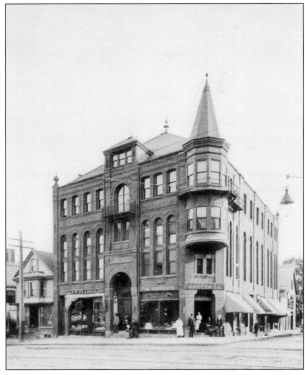

The Odd Fellows' Building was designed by local architect George F. Loring and built in 1885 at the corner of Broadway and Marshall Street. Odd Fellows, signified by the "three links," was developed in England and was based on friendship, love, and truth. On the first floor is Cheney & Company, a fine grocer. F.W. Pearson and Paul Revere Lodge No. 184 met in the apartments above.

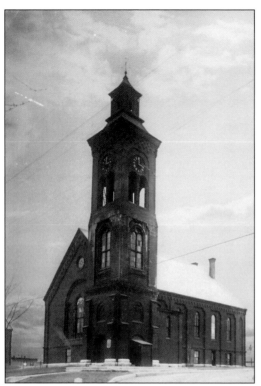

The First Unitarian Church was founded in 1844 and the first edifice was built on Highland Avenue, on the site of the high school. In 1893 the church and land was sold to the city of Somerville; the church was demolished when the English High School was built on its site.

The new edifice of the First Unitarian Church was designed by Hartwell and Richardson and built in 1894 on Highland Avenue, across the street from its original site.

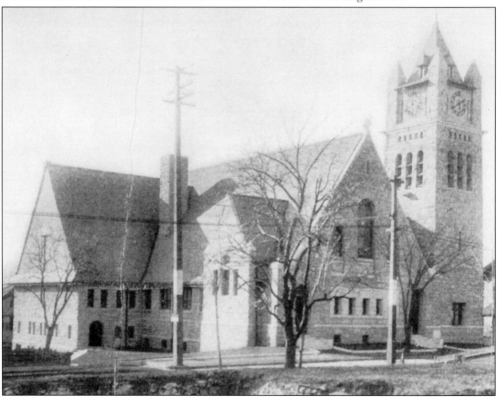

Three

Places of Worship

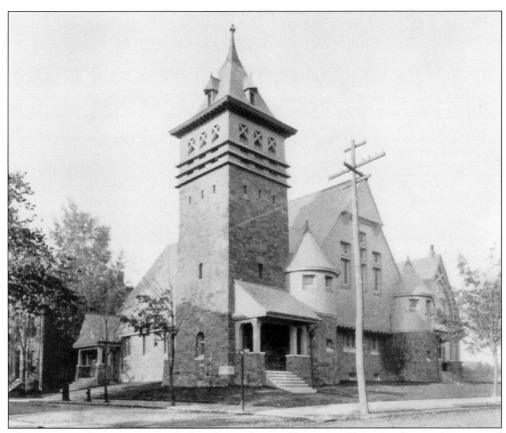

The Winter Hill Congregational Church was designed by Hartwell, Richardson and Driver and built in 1891 at the corner of Broadway and Central Street. A superb Shingle Style church with Romanesque Revival details such as turreted bays and a soaring stone tower, it still commands one's attention when approaching Winter Hill on Broadway.

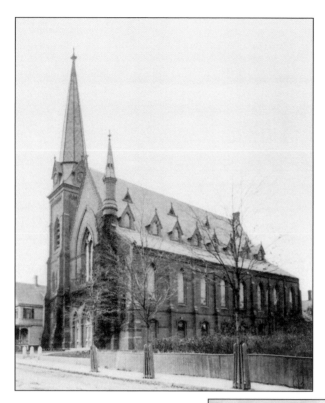

The First Orthodox Congregational Church was organized in 1853 and this edifice was built in 1868 on Franklin Street, opposite Perkins Street. The first pastor of this church was Reverend Benjamin Judkins.

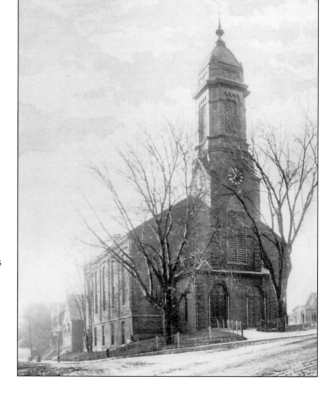

The First Universalist Church was built at the corner of Cross and Tufts Streets. The Universalists, who had organized a church in Somerville in 1854, later built a new church between 1916 and 1923 on Highland Avenue, which was designed by Ralph Adams Cram.

The Broadway Congregational Church was organized in 1864, a year after the Sunday school was formed and a church was built in 1868 on Sycamore Street on Winter Hill. This edifice was built in 1884, and a new Gothic front and Renaissance tower added in 1896.

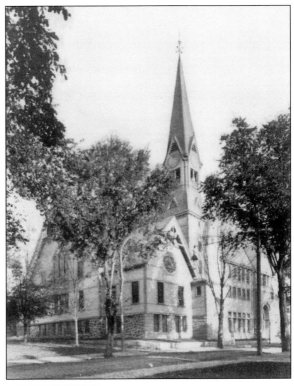

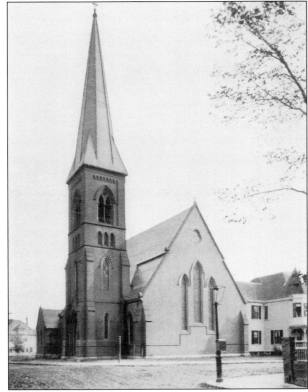

Emmanuel Episcopal Church was organized in 1862 in a hall above a tin-shop at the corner of Somerville Avenue and Park Street. This edifice was designed by Samuel J.F. Bryant and was built in 1866 at the corner of Summer and Central Streets.

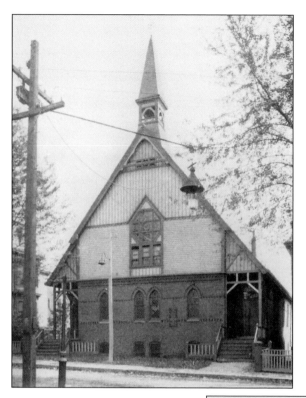

The Union Square Presbyterian Church was organized in 1886 and the church members purchased the former edifice from the Congregational Society, which was on Warren Avenue.

The First United Methodist Episcopal Church was organized in 1855 and services were held in Franklin Hall near Union Square. This edifice was built in 1874 at the corner of Bow Street and Wesley Park, beside the old Hawkins House. The steeple was unfortunately removed after the Hurricane of 1938.

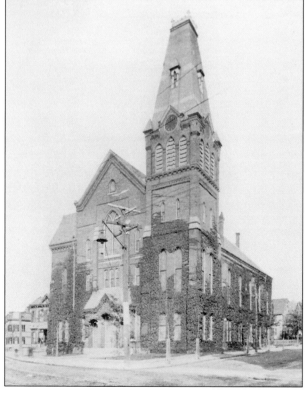

The First Baptist Church was organized in 1852 and services were held in a chapel on Beech Street for the first few years. This edifice was built in 1873 on Belmont Street, near Summer Street on Spring Hill.

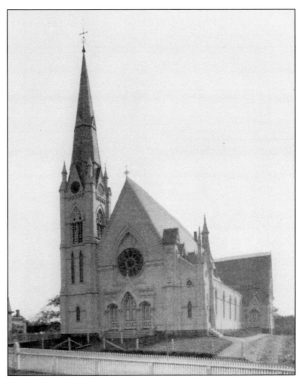

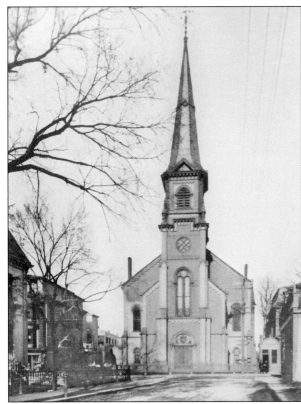

The East Somerville Baptist Church was organized in 1890 and this edifice was built on Perkins Street, opposite Pinckney Street. The first pastor was Reverend C.L. Rhoades.

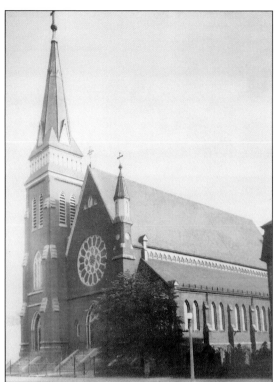

Saint Joseph's Church was the first Roman Catholic church in Somerville. Founded in 1869, the church was designed by James Murphy and built in 1874 at the corner of Washington Street and Webster Avenue in Union Square. An impressive brick Gothic church, its massive bell tower and lancet windows and doors still attract attention.

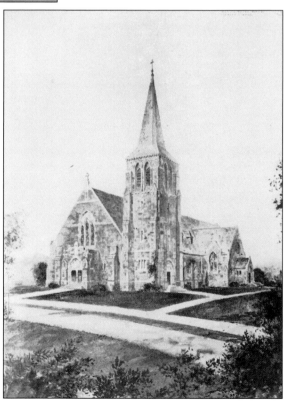

Immaculate Conception parish was formed in 1926. The church on the Alewife Brook Parkway was built in 1928.

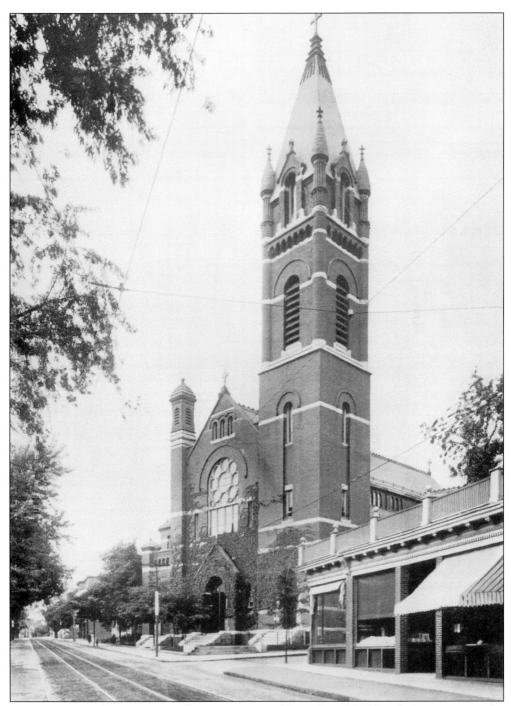

Saint Ann's parish at Winter Hill was once part of Saint Joseph's Church, but was created a separate parish in 1881 with Reverend John Galvin as the first pastor. This church was probably designed by Keeley and Houghton and was built in 1897 at the corner of Medford and Thurston Streets. An impressive red brick Romanesque Revival church, the bell tower made quite a statement upon completion.

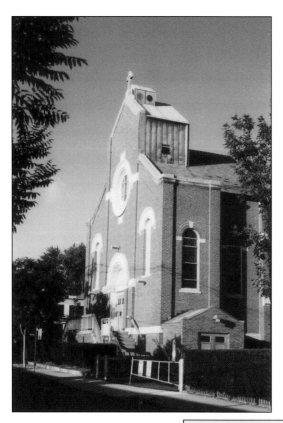

Saint Anthony of Padua Church is considered the "Italian" church in Somerville and was founded in 1915 on Somerville Avenue. The church's exterior is impressive, but the interior is lavishly furnished with marble altars from Carrara, Italy.

Saint Catherine of Genoa Parish was part of Saint Joseph's Church until 1891, when the new parish was formed. The church was designed by Charles D. Maginnis and was built on Summer Street, the first Mass being said in the upper church on Easter 1920. Saint Catherine's has often been referred to as "one of the most beautiful churches in America."

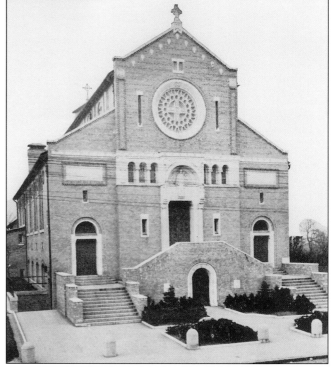

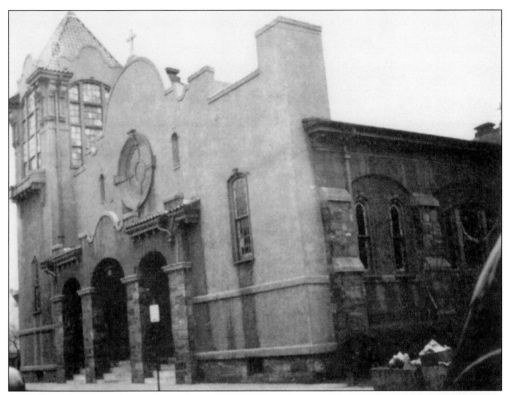

Saint Benedict's parish was formed in 1911, and derived its name from Mount Benedict—the old Ursuline Convent and Academy for Girls on Ploughed Hill. Designed by Edward T.P. Graham in the then-popular Spanish Mission style with concrete with stucco ornamentation, it was built at the corner of Hathon, Arlington, and Franklin Streets.

Saint Clement's parish was formed in 1912. The present church was designed by Richard Shaw and built in 1946 as a new church built entirely around the old church, after which the old church was demolished. Of "contemporary Christian construction," the sleek lines of Saint Clement's Church make for a distinctive, if not unique, church in Somerville.

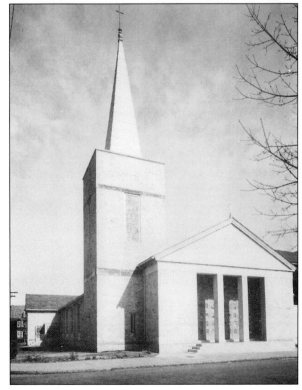

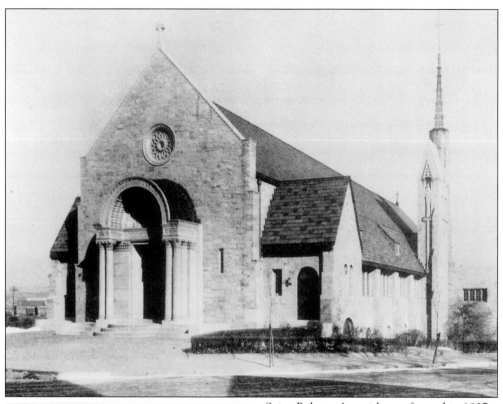

Saint Polycarp's parish was formed in 1927, the first Mass being said on Christmas 1933 in the upper church. Saint Polycarp's, which was built at the corner of Temple and Jacques Streets, near Mystic Avenue, is an attractive stone church with an interesting stone and metal spire.

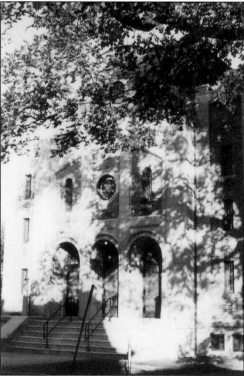

Temple B'nai Brith was designed by S.S. Eisenberg and built in 1922 on Central Street on Winter Hill near Broadway. Built of buff brick with limestone trim, it is a striking example of Byzantine architecture. A central dome is surrounded by four smaller domes which represent the four corners of the universe.

Four

SCHOOLS

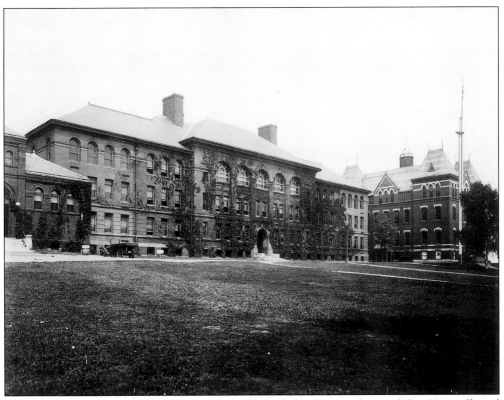

Somerville High School (built as English High School) was designed by Hartwell and Richardson and built in 1895 adjacent to the Latin High School. On the right is the Latin High School, and on the far left can be seen a corner of the old Somerville Public Library. (Courtesy of Anthony V. Fedele, headmaster of the Somerville High School from 1988 to 1997, and with thanks to David Rooney.)

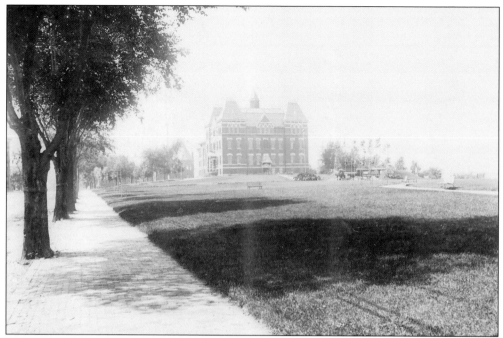

The Latin High School was designed by Samuel J.F. Thayer and built in 1871 on Highland Avenue, which can be seen on the left. The old Somerville Public Library, which was designed by Gorge Loring and built in 1884, can be seen to the left of the Ruskinian Gothic school. (Courtesy of the Somerville Public Library.)

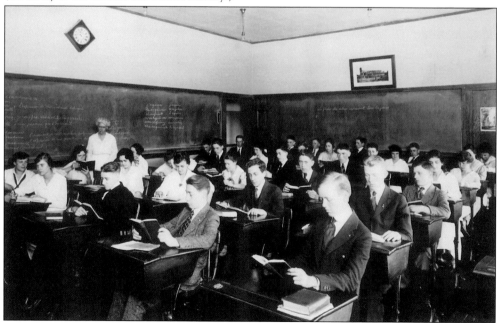

These Somerville High School students are studying French under the direction of Miss Browne in Room 305. Parlez vous francaise? Notice the diamond-shaped wooden electric classroom clock made by the Atlantic Clock Company of Boston. (Courtesy of Anthony V. Fedele, and with thanks to David Rooney.)

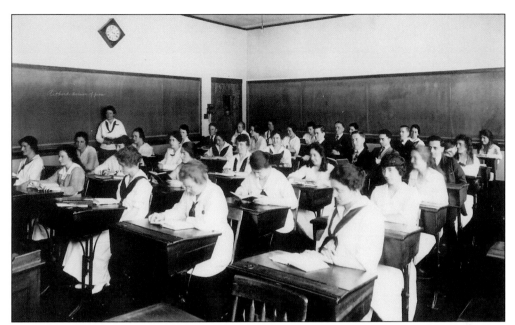

A classroom full of seemingly happy Somerville High School students studying English pose for their photograph about 1914. (Courtesy of Anthony V. Fedele, and with thanks to David Rooney.)

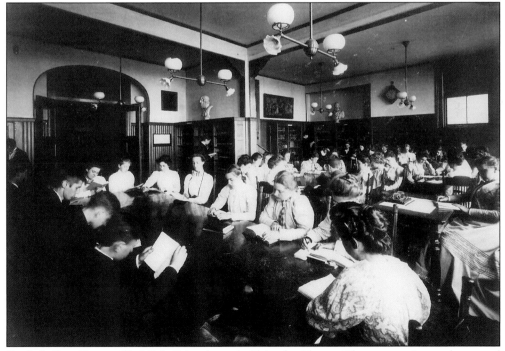

Study hall at Somerville High School was held in the library. These attentive students read from their books in a quiet and relaxing environment. (Courtesy of Anthony V. Fedele, and with thanks to David Rooney.)

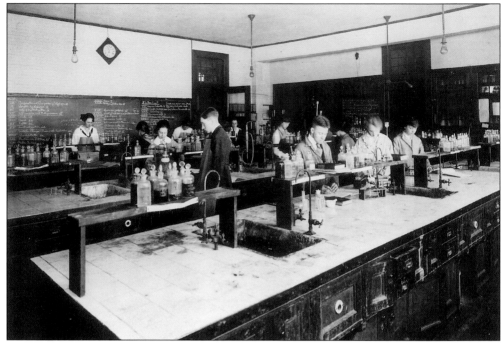

Students work in the chemical laboratory about 1910. With glass containers holding every sort of chemical, these classes could be a real blast, especially when specific chemicals were combined! (Courtesy of Anthony V. Fedele, and with thanks to David Rooney.)

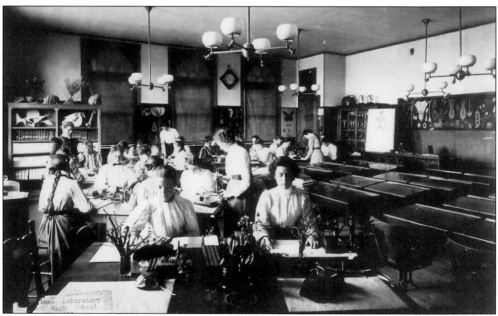

Students are in the physical laboratory at Somerville High School about 1896. Notice the microscopes that were used to magnify all sorts of things, such as flowers, crabs, and butterflies. (Courtesy of Anthony V. Fedele, and with thanks to David Rooney.)

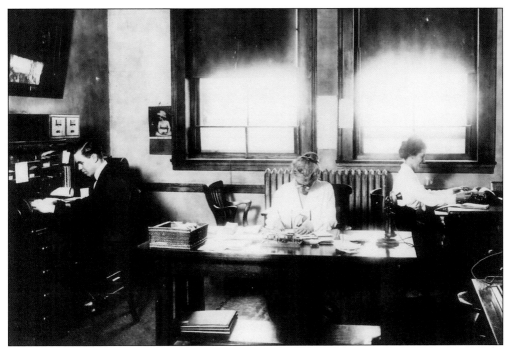

A busy place was the office at the Somerville High School! Notice the rolltop desk on the left and the hand-held telephone on the secretary's desk. (Courtesy of Anthony V. Fedele, and with thanks to David Rooney.)

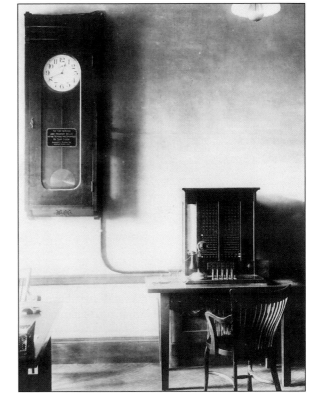

The telephone switchboard and the Blodgett Clock Company master clock were located in the office at the Somerville High School. This master clock was installed in 1905 and controlled all the classroom clocks and bells. (Courtesy of Anthony V. Fedele, and with thanks to David Rooney.)

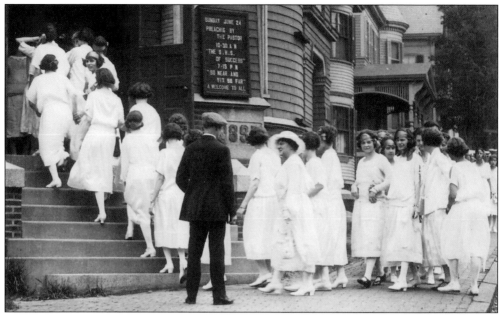

Marching into the Union Square Baptist Church are members of the Somerville High School graduation class of 1915. Dressed entirely in white, these young ladies seem to be the epitome of fashion. (Courtesy of the Somerville Public Library.)

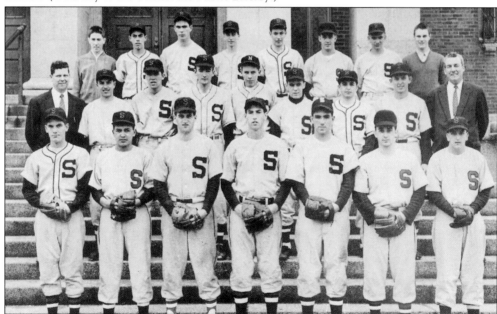

Play ball! The 1957 baseball team at Somerville High School included the following, from left to right: (front row) Hank Hogan, Joseph Cafarella, Robert Kavgian, Lonnie Fidalgo, James Brennan, Eddie Pignone, and Frank Spignese; (middle row) assistant coach James Palmer, Ernest Duarte, Paul Mc Namara, Marty O'Brien, Bob Pennell, Paul Gusdigian, Robert Duarte, and coach Donahue; (back row) Robert Preston, Dick Trinello, Tommy Brennan, Gennaro Di Sarcina, Joseph Caruso, Jimmy McCann, and Ronnie Del Vecchio. (Courtesy of the Somerville Public Library.)

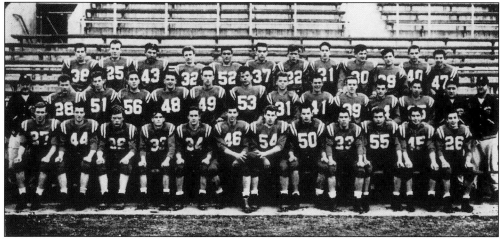

The football team in 1957 at Somerville High School pose for a group portrait on the bleachers. From left to right are as follows: (front row) Dave Mc Laughlin, Jerry Sullivan, Donald Cochran, Jack Brady, Jim McCann, co-captains Lonnie Fidalgo and Paul De Pasquale (holding a football), Harold Webber, Paul McNamara, Paul Tucelli, Cosmo Piccolo, and Bob Duarte; (middle row) coach Zammarchi, Ronnie Phelan, Ed Pasquanna, John Christopher, Bob Farrell, Sebastian Piccolo, Bob Murray, Richard Murray, Rod Beaton, Jim Corbett, Ed Capone, Bill Simone, coach Chello, and assistant coach Mavropolis; (back row) Jim Rockwood, Paul Riley, Joe Toscanno, John Burgess, Jim Chaprolis, Bob Wallace, Paul Dumas, Anthony Spartas, Eli Travassos, Dave Pignone, John Brady, and Ernie Duarte. (Courtesy of the Somerville Public Library.)

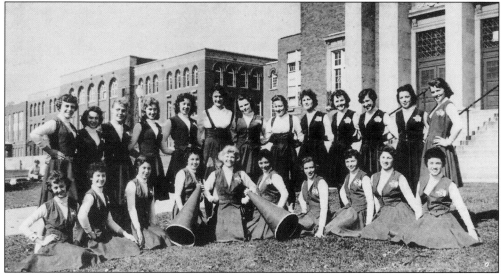

Cheerleaders in 1957 pose on the lawn in front of the high school in 1957. From left to right are as follows: (front row) Janice Rice, Margaret Buckley, Dorothy De Mita, Louise Noble, Betty Corelli, Carol Baldassari, Virginia Steeves, Nancy Faye, Nancy Resmini, and Lee Brongo; (back row) Glenda Park, Rose Volutrno, Regina Cole, Jean Fiske, Roberta Carlson, Janet Beres, Margaret MacQuaid, Judith Johnson, Ruth Cochran, Elinor Hopkins, Rosalyn Perrone, Lucille Ventura, and Priscilla Corbett. (Courtesy of the Somerville Public Library.)

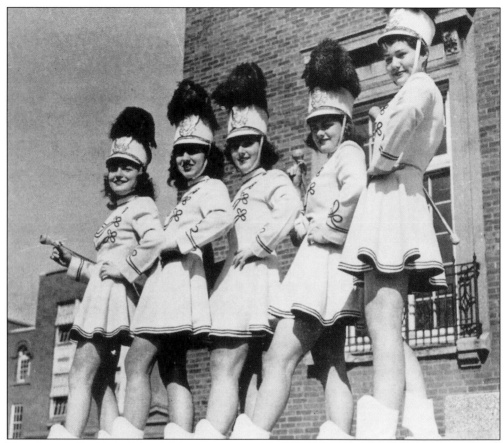

The Somerville High School Majorettes in 1957 included, from the left, Elaine Holland, Alda Andrade, Dorothy Fennessey, Charlotte Sheperd, and Betty Graham. (Courtesy of the Somerville Public Library.)

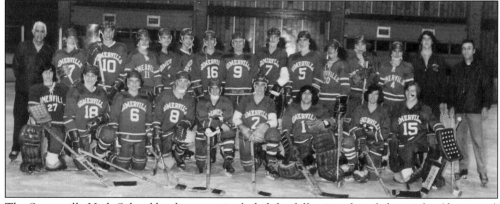

The Somerville High School hockey team included the following, from left to right: (front row) Tom Robbins, Jay Michison, Stephen Gay, D.A. Vivian, captain Dan Vivian, Phil De Lisia, Steve Vallesio, and Dennis Scheaffer; (back row) assistant coach Ray Deeran, Bill Crowley, Al Smith, Brian Thibault, Mark Guidi, David Perry, Joe Bonaventura, Jack Johnson, Tom McDonald, Ernie Palmacci, Tony Giannone, Robert Linehan, John Ventura, manager Jim Carafotes, and coach George Renault. (Courtesy of the Somerville Public Library.)

The Walnut Hill School was built in 1843 on Broadway near Cedar Street. A simple one-story Greek Revival schoolhouse, it was the first schoolhouse built after Somerville became an independent town. In 1868, the school was moved to Cedar Street and was henceforth known as the Cedar Street School. (Courtesy of the Somerville Public Library.)

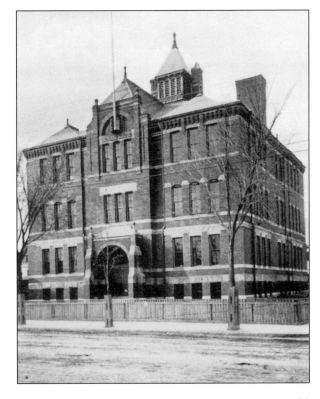

The Highland School was built in 1880 on Highland Avenue in West Somerville. By 1902, there were twenty-five schools in Somerville—serving a population of 61,643 (there were 1,013 residents in 1842 when Somerville became an independent town.) A few schools, to represent the large number of them, follow with the person for whom they were named. (Courtesy of David Rooney.)

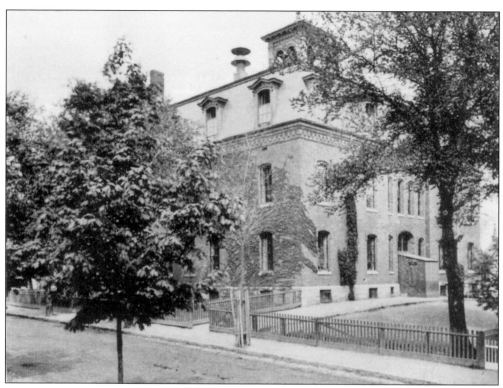

The Forster School was built in 1866 on Sycamore Street on Winter Hill. (Courtesy of David Rooney.)

Charles Forster (1798–1866) was engaged in mercantile pursuits and was a philanthropist of the town. He moved to Somerville in 1845 and "was always interested in the public welfare."

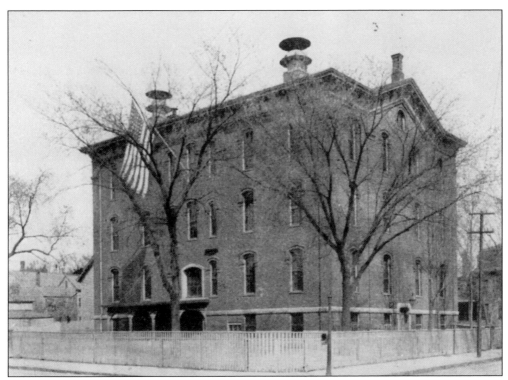

The Prescott School was named in memory of William H. Prescott (1796–1859) and built in 1867 on Pearl Street in East Somerville. A noted historian, Prescott was author of the *History of Ferdinand and Isabella*, *Conquest of Mexico*, and *Life of Charles V*. His home is on Beacon Street in Boston and is preserved as a museum by the Colonial Dames of Massachusetts. (Courtesy of David Rooney.)

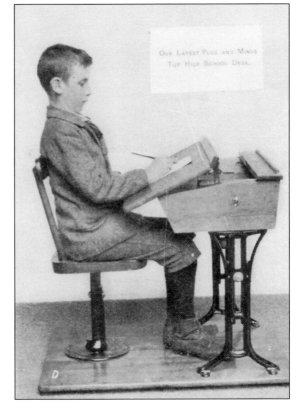

Many of Somerville's schools were furnished with desks and chairs from the Chandler Adjustable Chair and Desk Company. A student sits at a "Plus and Minus Top High School Desk," which was used in the English High School. (Courtesy of David Rooney.)

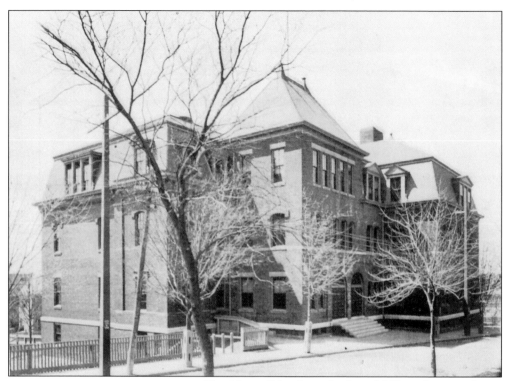

The Morse School was built in 1869 on Summer Street on Spring Hill. (Courtesy of David Rooney.)

Enoch R. Morse, a businessman in Boston, represented Somerville in the legislature in 1876 and so "highly were his services appreciated by the town government that his name and memory were perpetuated in the Morse Grammar School."

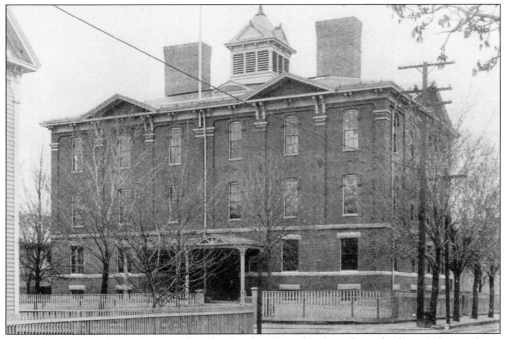

The Edgerly School was designed by Shepherd S. Woodcock and was built in 1871 on Cross Street in East Somerville. (Courtesy of David Rooney.)

John S. Edgerly (1804–1872) was a member of the board of selectmen of Somerville, a member of the school board, and an overseer of the poor. It was said of him that "no night was too dark or road too bad for him to start with his lantern and shovel to break out any place that his horse could not get through, whenever there was need."

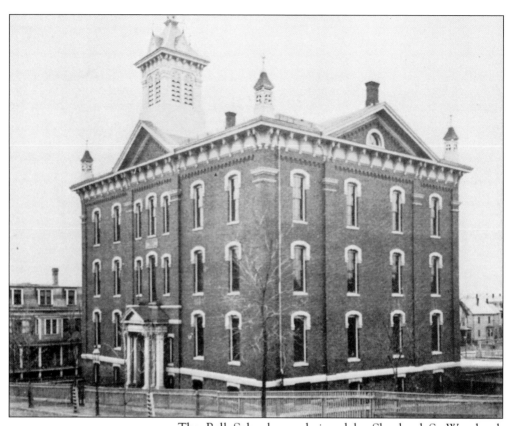

The Bell School was designed by Shepherd S. Woodcock and was built in 1874 on Vinal Avenue on Prospect Hill. By vote of the Somerville School Board, the primary school on Cherry Street was named in his memory. This school was named for Dr. Bell after the old school was closed in 1867. (Courtesy of David Rooney.)

Luther V. Bell, VMD, LL.D (1806–1862), was the first chairman of the Somerville School Board, and was a distinguished physician well known for his competence "in surgery and in the treatment of the insane." He was associated with the McLean Asylum for twenty years and was "acknowledged as an authority on all questions connected with his profession."

Five

THE LIBRARY

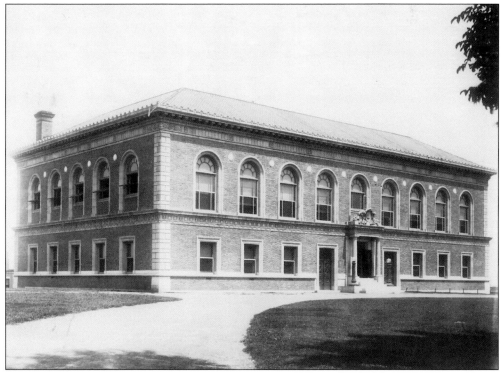

The Somerville Public Library, founded in 1871, was designed by Edward Lippincott Tilton and built in 1914 on Highland Avenue through city funds and a generous donation by Andrew Carnegie, founder of the Carnegie Foundation. Tilton had studied at the Ecole des Beaux Arts in Paris and was an architect with McKim, Mead and White when they designed the Boston Public Library in Boston. With large arched windows across the facade and a Renaissance Revival aspect to the library, it has many similarities to the Copley Square Library in Boston. (Courtesy of the Somerville Public Library.)

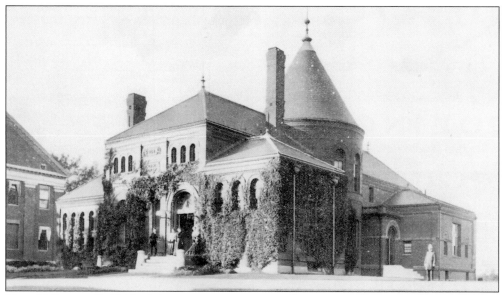

The old Somerville Public Library was an interesting Romanesque Revival structure with an enormous turreted tower in the center. It was built in 1884 adjacent to Somerville City Hall on Central Hill and was designed by George F. Loring (1851–1918), a Somerville architect who lived at 76 Highland Avenue and who was a partner in the architectural firm of Phipps and Loring.

Sam Walter Foss (1858–1911) was the librarian of the Somerville Public Library from 1898 to 1911. A well-known writer, his poetry attracted great attention. His books of poetry *Back Country Poems*, *Whiffs From Wild Meadows*, *Dreams in Homespun*, *Songs of War and Peace*, and *Songs of the Average Man* were published between 1892 and 1907. His poem *The House By the Side of the Road* is poignant one and a few lines of verse say "Let me live in my house/By the side of the road/And be a friend to man."

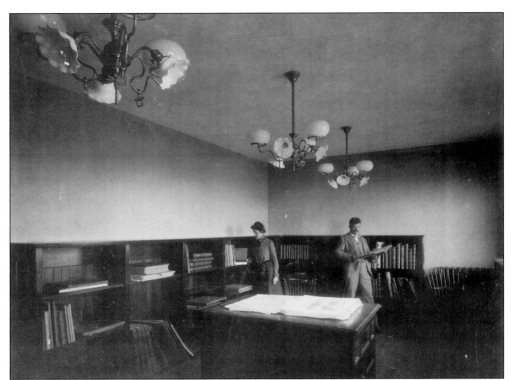

Sam Walter Foss, librarian of the Somerville Public Library, and an assistant look through books in the art room of the old library. The art room had photographs of the pictures in great European galleries that could be borrowed just like a book. (Courtesy of the Somerville Public Library.)

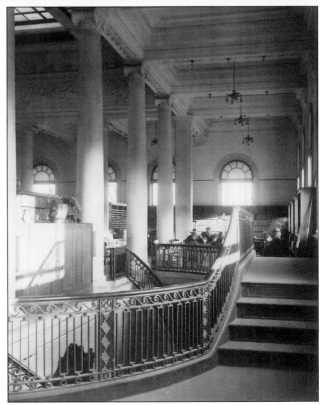

The original staircase leading to the second-floor reading room of the Somerville Public Library was a dramatic approach to the reading room and bookstacks. The huge arched windows allowed copious amounts of light to enter and the Ionic columns created a classical colonnade that not only supported the roof, but created a dramatic and impressive space. (Courtesy of the Somerville Public Library.)

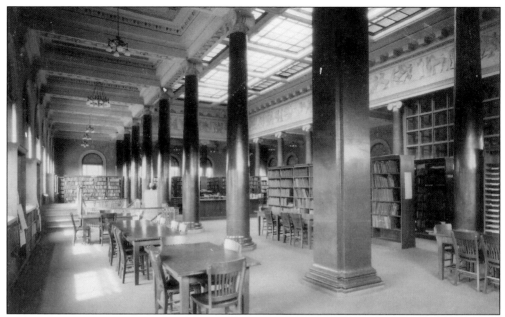

The second floor of the Somerville Public Library had monumental Ionic columns supporting the roof with a plaster frieze of the Parthenon, the original of which was once part of the Acropolis in Athens, Greece. (Courtesy of the Somerville Public Library.)

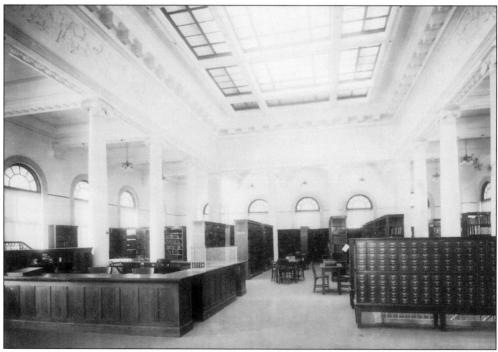

The reading room at the Somerville Public Library was photographed in the 1920s. On the left is the librarian's charge desk and the card index can be seen on the right. In the rear, the bookstacks seem to march down the center of the room. (Courtesy of the Somerville Public Library.)

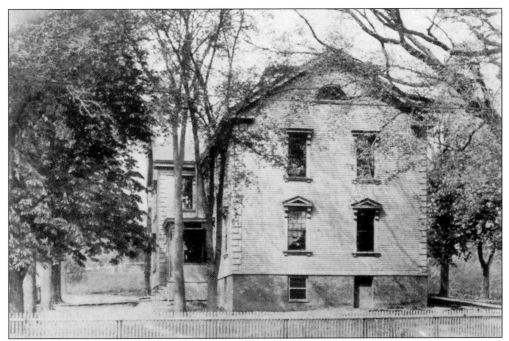

The Union Square Branch of the Somerville Public Library was opened in 1912 in the former Prospect Hill School House, at the corner of Washington Street and Bonner Avenue. (Courtesy of the Somerville Public Library.)

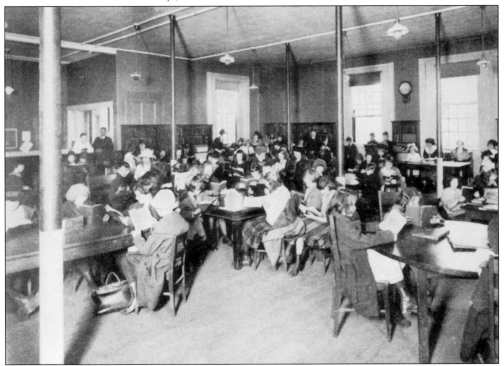

The children's room at the Union Square Branch of the Somerville Public Library was as busy as it was popular on afternoons following school. (Courtesy of the Somerville Public Library.)

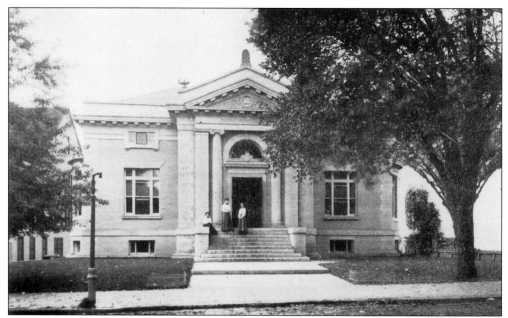

The West Somerville Branch of the Somerville Public Library was designed by McLean and Wright and built in 1909 on College Avenue through the generosity of the Carnegie Foundation. A Renaissance Revival library, its classical details such as recessed Ionic columns and a dentiled pediment make for an impressive addition to Davis Square. Three young ladies pose on the entrance steps in 1911.

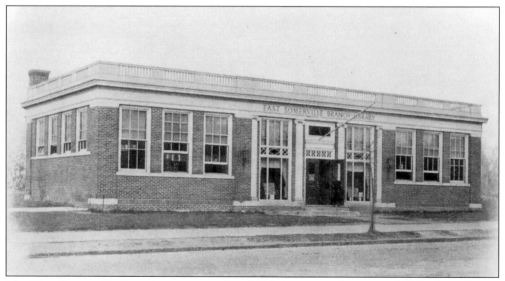

The East Somerville Branch was opened in 1912 in a rented store at 153 Perkins Street. Through the generosity of the Carnegie Foundation, the present library was built in 1918 at the corner of Broadway and Illinois Avenue. Other branches of the library were the Winter Hill Station (opened in 1929) and Ten Hills Station (opened in 1940). (Courtesy of the Somerville Public Library.)

Six

ALL MODES
OF TRANSPORTATION

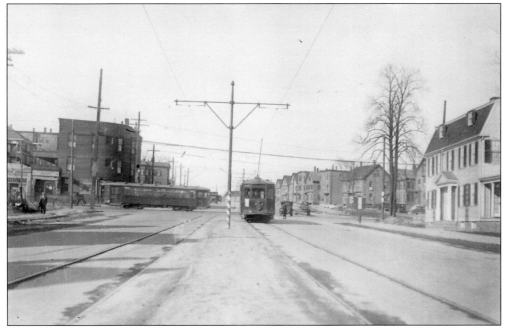

Two streetcars can be seen at the junction of Washington Street and the Northern Artery (O'Brien Highway) in 1927. The Northern Artery was designed as a cross-town road for automobiles and was built in 1925 from the Charles River Basin at Lechmere Square to Broadway (now Foss) Park and the Fellsway—a direct route into Boston. (Courtesy of Frank Cheney.)

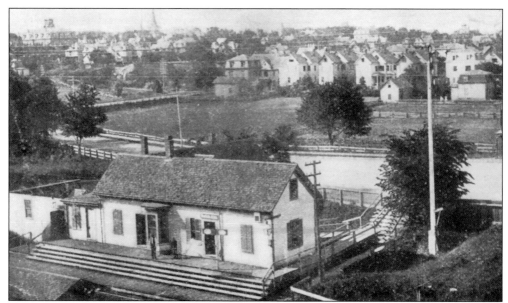

The old Winter Hill Station, shown here with Gilman Square in the distance, was a one-story wood-framed building for passengers waiting for the train going to Boston. In 1835, the Boston and Lowell Railroad was laid through Somerville, followed by the Fitchburg Railroad in 1842, the Boston and Maine in 1845, and the Eastern Railroad in 1854. The original railway cars were small open wagons with seats facing one another with no overhead protection—either from sparks or engine smoke! (Courtesy of the Somerville Public Library.)

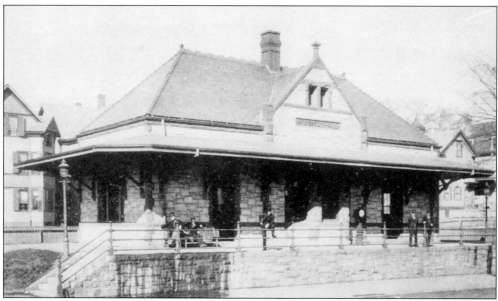

The Prospect Hill Station on the Boston and Maine Railroad was an impressive rough hewn granite depot with Romanesque Revival details that was designed by Alden Frick. In 1886 "a total of thirty two week-day and nineteen Sunday trains stopped at Prospect Hill" depot. One can imagine the large number of residents utilizing this service and the net results—increased population due to the convenience of transportation.

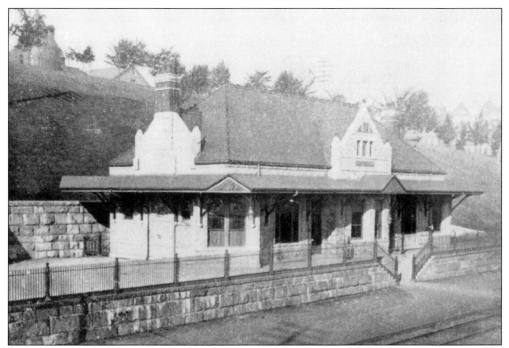

The Winter Hill Station on the Boston and Maine Railroad was designed by Alden Frick of red marble ashlar trimmed with rock-faced marble from Isle la Mont, Vermont. The waiting room had such impressive details such as a marble-and-cherry-trimmed fireplace and birch paneling—all of which attracted new residents.

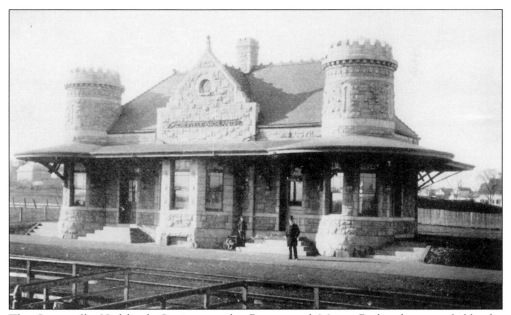

The Somerville Highlands Station on the Boston and Maine Railroad was probably the most interesting, with Alden Frich having designed crenelated towers that flanked a central projecting dormer from the roof.

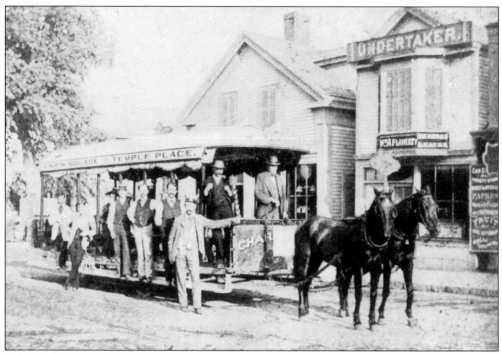

A horse-drawn streetcar stops on its Union Square, Somerville, to Temple Place, Boston, run in front of William A. Flaherty's undertaking parlor. The first "horescars" in Somerville were seen in 1858 and would ultimately prove to "add to the future prosperity of the town."

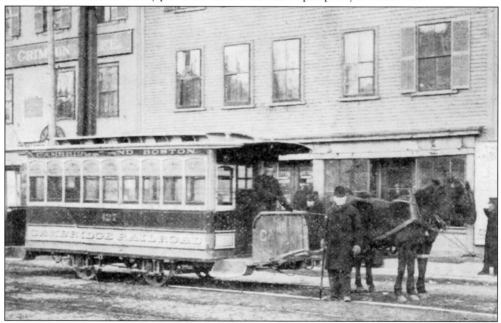

A Cambridge Railroad Horsecar stops in Union Square about 1885. These horse-drawn streetcars ran along tracks that were laid down the center of the streets. After electrification, the streetcars utilized the rails, minus the horses, but with a maze of overhead wires crisscrossing intersections. (Courtesy of the Somerville Public Library.)

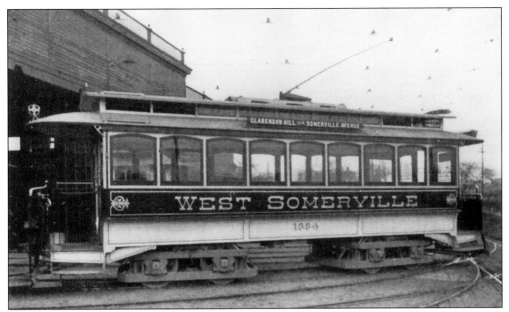

This was a modern (1900 modern that is) electric car of the West End Street Railway that was photographed outside the Clarendon Hill Carbarn. This streetcar travelled Clarendon Hill via Somerville Avenue in West Somerville.

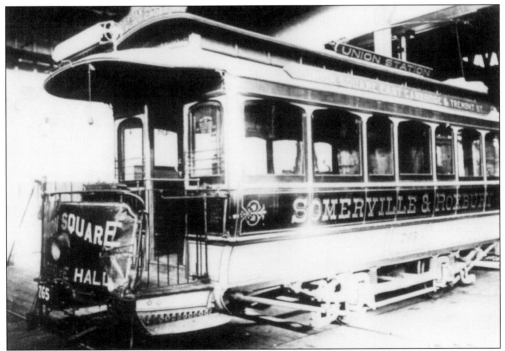

A Somerville streetcar (Number 765) of the type used on the Union Square to Roxbury Crossing "Crosstown Line" was photographed in 1895 in the carbarn. These streetcars ran a circuitous route from Union Square in Somerville to East Cambridge, across the Charles River via Massachusetts Avenue, and finally along Tremont Street to Roxbury Crossing—and then back. (Courtesy of Frank Cheney.)

Broadway stretches the entire length of Somerville and connects Charlestown and Arlington. A streetcar travels west on Broadway in 1924, and Broadway (later Foss) Park can be seen on the left. In the distance can be seen the crenelated tower of the firehouse at the corner of Broadway and Cross Street, which is now the Cross Street Senior Center. (Courtesy of Frank Cheney.)

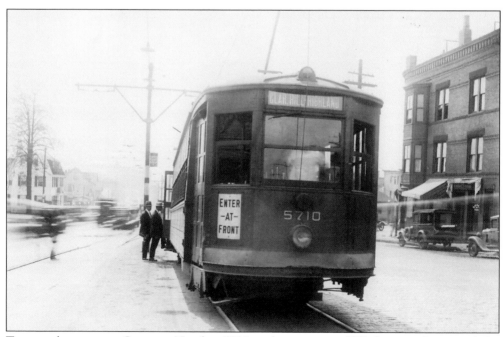

Two gentlemen enter Streetcar Number 5710 at the junction of Washington Street and the Northern Artery (now known as McGrath Highway) in 1925. (Courtesy of Frank Cheney.)

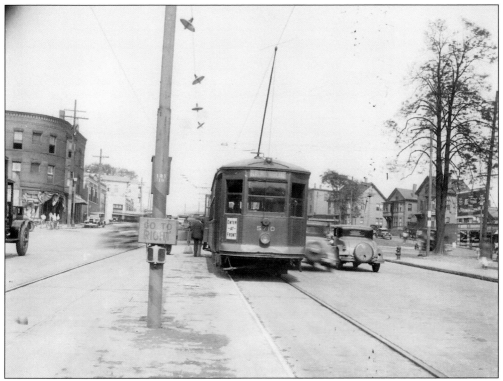

A Number 5 Streetcar (Car 5710) was photographed in 1926 at the junction of Washington Street and the Northern Artery (now known as McGrath Highway). This streetcar line serviced Clarendon Hill and Highland Avenue. (Courtesy of Frank Cheney.)

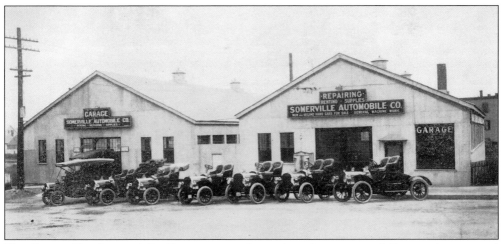

The Somerville Automobile Company was located at the corner of Boston Avenue and Broadway in West Somerville. In front of the garage are a few "Rambler" cars that had been sold to local residents. In their advertisement, they said "We have four more of these cars ready for immediate delivery. Telephone or call for demonstration." Who could resist the new "horseless carriages?" (Courtesy of the Somerville Public Library.)

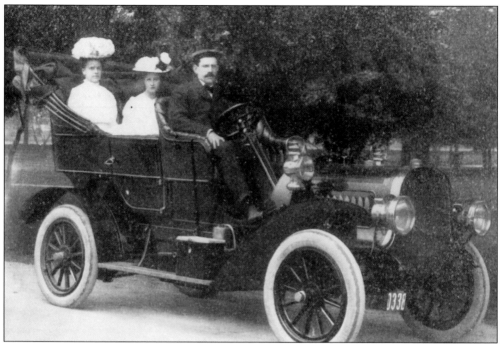

Frederick A. Dutton, manager of the Somerville Automobile Company, sits behind the wheel of a "Model 21 Rambler Demonstrating Car" with his wife and a friend sitting in the rear seat. (Courtesy of the Somerville Public Library.)

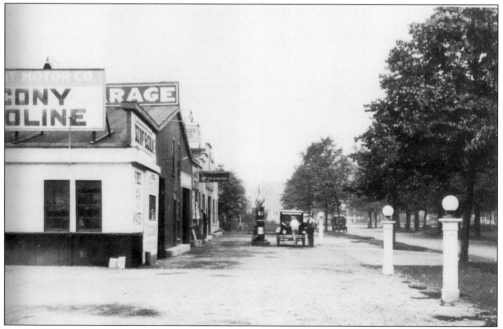

By the 1920s the automobile had carved out a niche in American society. Here, a car is stopped at the fuel pump of the Socony Gasoline Station, which was at the junction of Mystic Street and the Fellsway. The trees on the right border Broadway Park. (Courtesy of the Somerville Public Library.)

Seven

A Streetcar Suburb

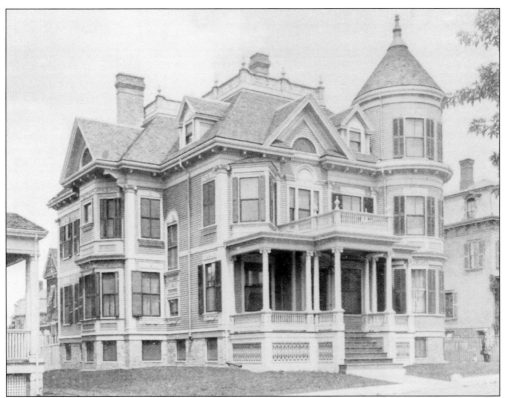

The home of Henry E. Wright was designed by local architect Shepherd S. Woodcock and built at 31 Pearl Street. A superb example of the quintessential home of the late nineteenth century, it combined Queen Anne details with the emerging Colonial Revival style of architecture such as the corner pilasters with Ionic capitals, swag panels above the windows, and a modified palladian window on the second floor. Henry Wright was a prosperous milk can manufacturer.

Charles D. Elliot was city engineer for Somerville, author of *Somerville's History*, and the first president of the Somerville Historical Society. Founded in 1897, and celebrating its centennial this year, the Somerville Historical Society was originally headquartered in the old Tufts House on Sycamore Street. The present headquarters of the society is at the corner of Westwood Road and Central Street, which was designed by William Dykeman and built in 1933.

The home of Charles B. Wyman was built at 67 Thurston Street. An interesting Queen Anne-style house, the roof has a multitude of hooded dormers and gables projecting from every side that creates an unique appearance. The piazza wraps around the house and offered a place to watch life go by a century ago. The Winter Hill Universalist Church, with its interesting tower, can be seen on the right.

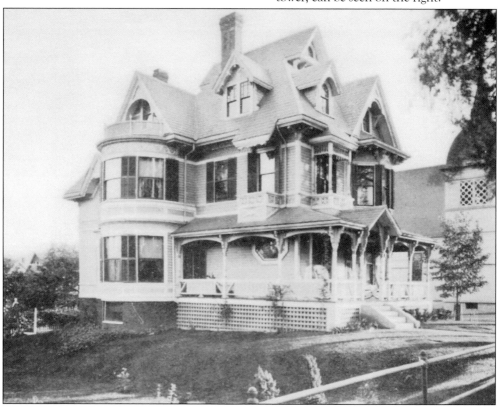

General Charles H. Taylor (1846–1921) was born in Charlestown and became an editor and founder of the *American Homes Magazine*, the first 10¢ magazine in this country. Taylor was later publisher and editor off *The Boston Globe*. He and his first wife, Georgiana O. Davis, lived on Spring Hill in Somerville and were members of the First Methodist Church.

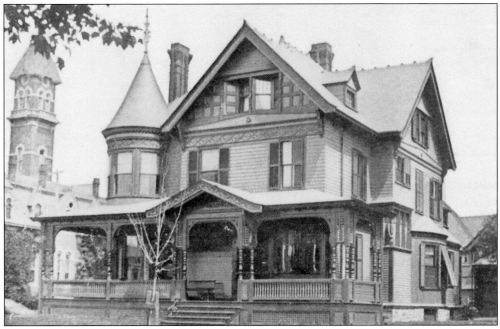

The home of Horace E. Hall was built at 25 Highland Avenue. A Queen Anne house, it has an impressive piazza with a corner tower capped with a conical roof. The front gable was embellished with strap-paneling and shingling. On the left can be seen the tower of the Central Fire Station on Highland Avenue.

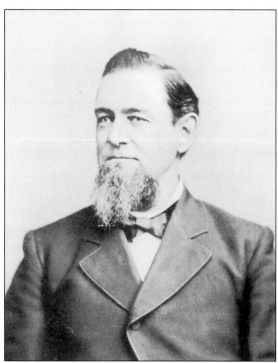

Stephen W. Fuller was born at Crafts' Corner, now known as Thompson Square, in Charlestown. A resident of Somerville since 1860, he was a lumber dealer who supplied Somerville with much of the lumber necessary to build the new houses. So extensive was his business that he carried on "a very large business, the railroad cars running into his yard direct from the mills of all parts of the country."

Stephen Fuller built his own home in 1861 at 151 Walnut Street. A simple three-bay facade, this house was relatively unadorned except for flanking bays on either side of the front porch.

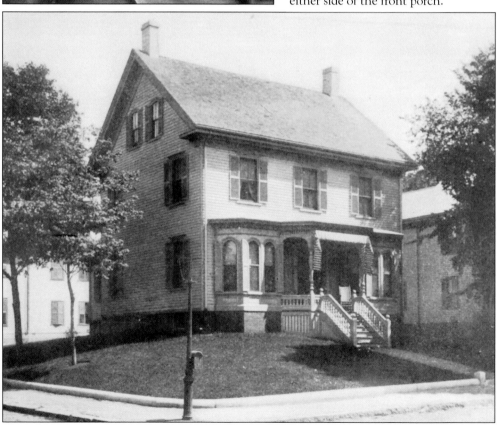

The home of Edward Cox was built at 36 Central Street. An impressive three-story corner tower created a dramatic aspect to a relatively simple Victorian house. An immigrant from England, Cox moved to Somerville in 1870 and an active dealer in local real estate.

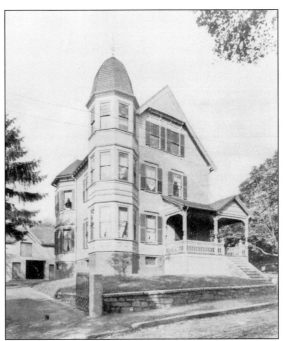

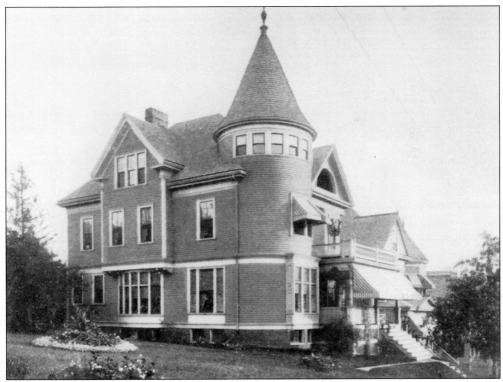

The home of George W. Bentley was built at 19 Adams Street on Winter Hill. A large Queen Anne house, the rounded tower had a strap of windows just below a soaring conical roof. An immigrant from England, Bentley was proprietor of the G.W. Bentley Company, which transacted business as manufacturers' agents.

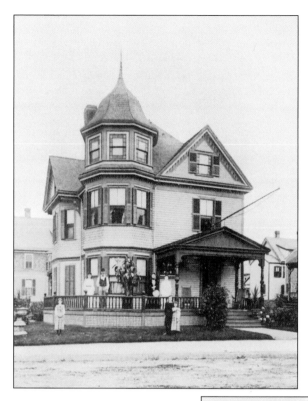

The home of Charles H. Lockhardt, a successful undertaker in Somerville, was built at 352 Elm Street (later 88 College Avenue when this stretch of Elm Street was renamed at the turn of the century). A fanciful Victorian house, it had clapboards and cut-work shingles as well as stained-glass window surrounds. The entire Lockhardt family stands on the porch and front lawn in this photograph from 1892.

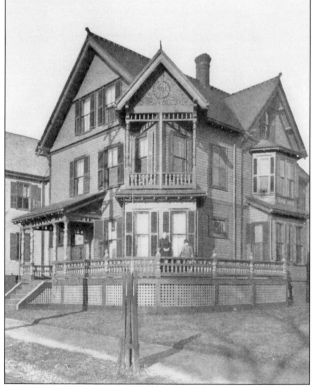

The home of Lyman B. Rich was built at 381 Medford Street. A sea captain who followed the sea, Captain Rich moved to Somerville in 1878 and retired from the sea to open Atwood and Rich, a ship brokerage and steamboat agency in Boston. Mrs. Rich and her son stand on the porch in front of the parlor windows.

The Honorable Robert Luce once served as lieutenant governor of the Commonwealth of Massachusetts. It was said that Luce was "a statesman in the broadest sense; he has served the state long and well, and has added to the dignity and renown of the Commonwealth."

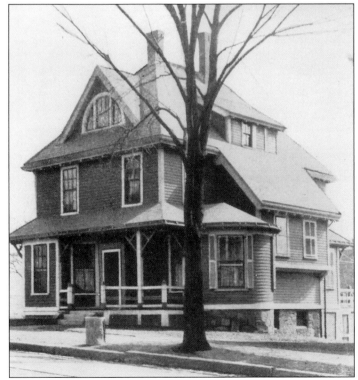

The home of Lieutenant Governor Robert Luce was a Stick Style house that was built at 44 (now 140) Highland Avenue. Luce was a well-known journalist and author of *Electric Railways, Writing for the Press,* and *Going Abroad?*

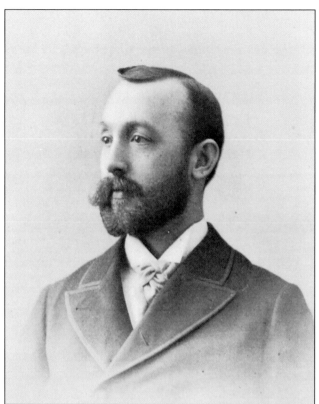

Frank A. Teele was a prominent real estate dealer whose office was in Davis Square, Somerville. Purchasing the coal and wood business of Colonel S.M. Fuller in 1895, he dealt with not only the sale of houses, but also provided the means to heat them.

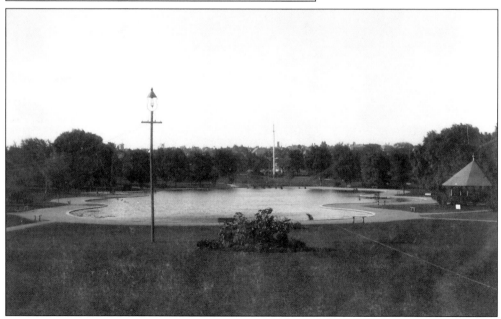

Broadway Park was designed by City Engineer Charles Elliot between Broadway and Mystic Avenue and Fellsway West and the Northern Artery (McGrath Highway.) The park was laid out in 1875 on marshy lowlands that was transformed into a lush greenspace with a large pond in the center and playing fountains. (Courtesy of the Somerville Public Library.)

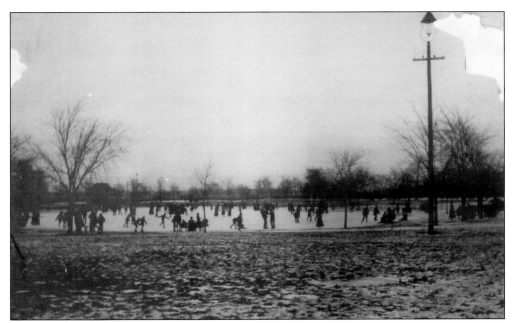

Skaters enjoy a winter afternoon at Broadway (later Foss) Park at the turn of the century. (Courtesy of the Somerville Public Library.)

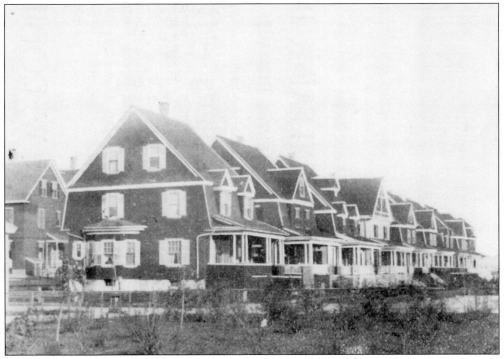

These Colonial Revival houses were built on Highland Road, Highland Park, in the Somerville Highlands. Offered by W.P. Rice, a leading real estate agent at 371 Highland Avenue and "Pioneer of modern homes at popular prices and easy terms," his advertisements said "Come and buy a home you will be proud of. Easy terms so you can soon be your own landlord." (Courtesy of the Somerville Public Library.)

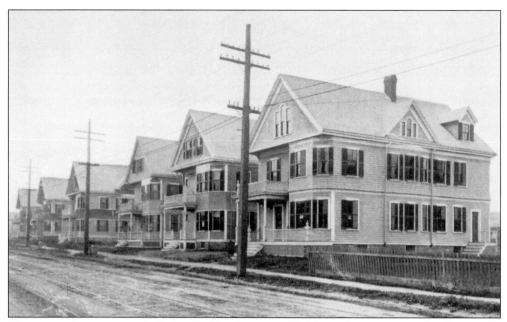

These new houses were built by C. Hazeltine on Highland Avenue near the Somerville Highlands Station of the Boston and Maine Railroad. Built as speculative houses, they attracted new owners from all parts of the state.

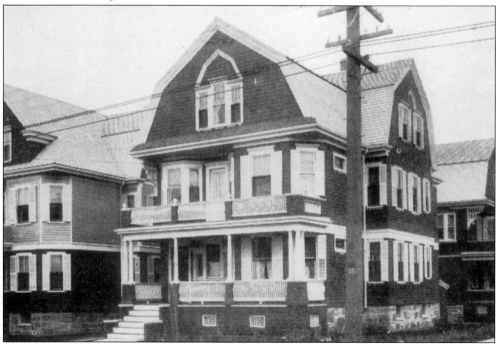

A Colonial Revival two-family house that was built by H.D. Mc Gray on Broadway in the early twentieth century was as architecturally pleasing as it was spacious. With a series of gambrel dormers, octagonal bays, and a front piazza, these houses created a streetscape that pleased the eye. The two-family house also offered an apartment for the owner and a rental unit that could assist in paying the mortgage.

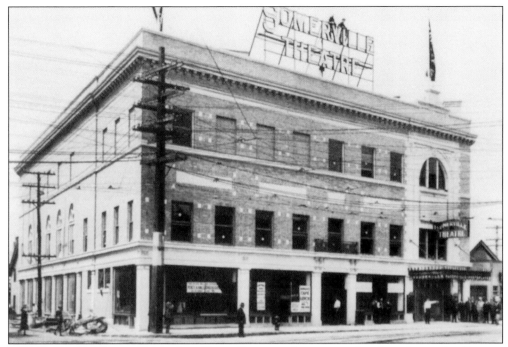

The Somerville Theatre was built in Davis Square and was a popular place for vaudeville acts, theatre, and later silent and talking movies. The three-story building, which has recently been renovated, was designed by Funk and Wilcox and built in 1912. Notice the patrons under the canopy on the far right. (Courtesy of the Somerville Public Library.)

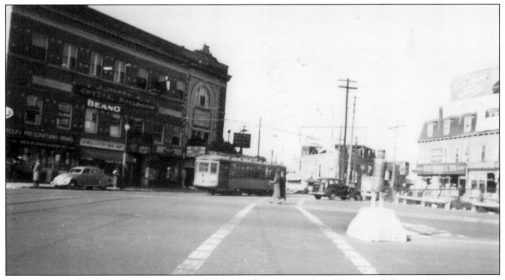

Davis Square has long been a thriving business district, as this photograph from 1937 can attest. The Somerville Theatre (on the left) has stores on the first floor with a large sign above that advertised Hobbs' Crystal Ballroom and Beano! A streetcar approaches Davis Square from Holland Street. (Courtesy of Frank Cheney.)

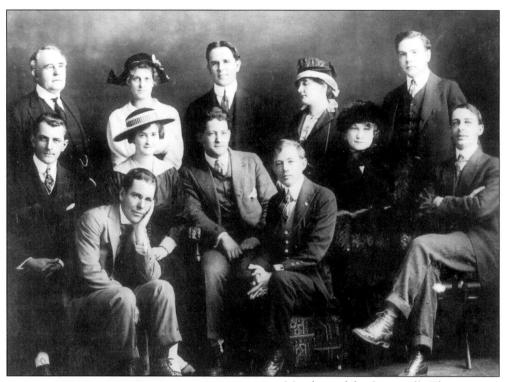

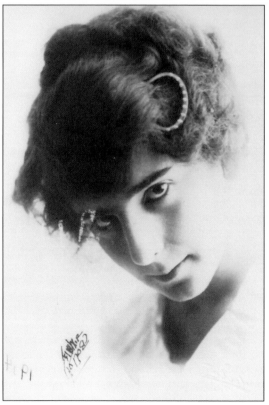

Members of the Somerville Theatre Stock Company during the 1915–16 season included the following, from left to right: (front row) Wilmer Bentley and Elbert Benson, assistant director; (middle row) Brandon Evans, Evelyn Varden, G. Swayne Gordon, Eleanor Armstrong, and G. Ellwood Farber, director; (back row) Tom Burroughs, Dorothy Beardsley, Howard Alger, Ethel Townsend, and George Carlton. (Courtesy of the Somerville Public Library.)

Louise Skinner was an actress in the Somerville Theatre Stock Company during 1915 and 1916. (Courtesy of the Somerville Public Library.)

Eight

McLean, Somerville, and a Few Other Hospitals

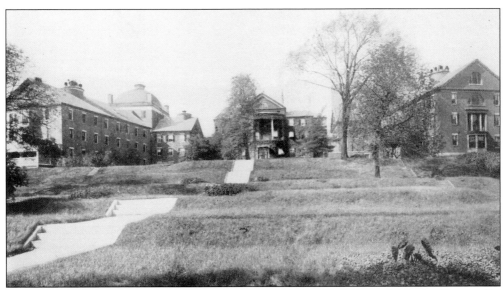

The McLean Asylum was probably the most important institution ever established in Somerville. The central building was designed in 1792 by Charles Bulfinch (1763–1844) as the summer house of Boston merchant Joseph Barrell. In 1816, the estate was sold to the Massachusetts General Hospital for an asylum for the mentally ill and was named for John McLean, a generous benefactor of the hospital whose wealth was derived from the paper mill of Boies and McLean on the Neponset River in Milton. Over the next few years flanking wings were designed by Bulfinch and the grounds were laid out with walks and terraced lawns for the patients. The hospital moved to Waverly in Belmont, Massachusetts, in 1895.

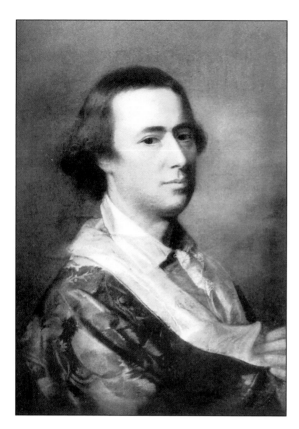

Joseph Barrell was a wealthy merchant in Boston whose townhouse was on Summer Street in the old South End of town. He had hired Charles Bulfinch to work in his counting house; however architecture and design won out over business. Barrell's mansion was called "Pleasant Hill" and was built on Cobble Hill in 1793. The drive to the house was lined with elm trees, and with European gardens and fountains for goldfish, it must have been a splendid sight to behold.

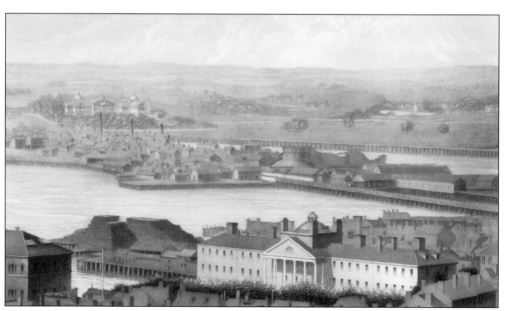

The Massachusetts General Hospital was designed by Charles Bulfinch and built in 1818 on McLean (later Fruit) Street near the Charles River. In the distance, on the upper left, McLean Hospital can be seen on Cobble Hill in Charlestown, later Somerville.

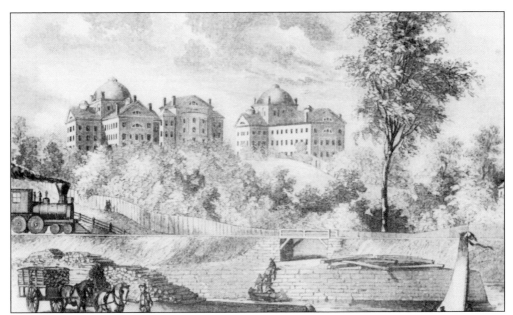

After the flanking wings were built on either side of the former Barrell Mansion, the McLean Asylum created quite an impression. Overlooking Miller's River, the grounds of the asylum were hemmed in by the railroad (notice the engine on the left) and river traffic. (Courtesy of the Somerville Public Library.)

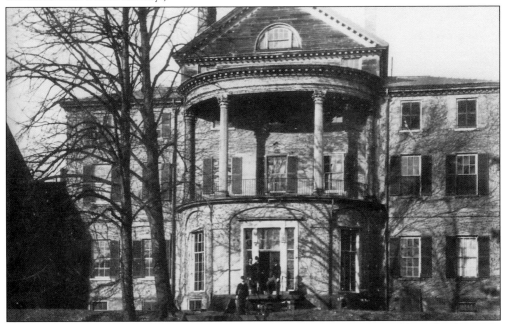

The McLean Asylum's main building, the former Barrell Mansion, retained much of its neoclassical elegance even as late as 1895, when the property was sold and the hospital was to be moved to Waverly. The center pavilion had Corinthian columns supporting a curved cornice and recessed windows set in the bay that supported the balcony. A group of hospital administrators stand on the steps leading from an elliptical room about 1890. (Courtesy of the Somerville Public Library.)

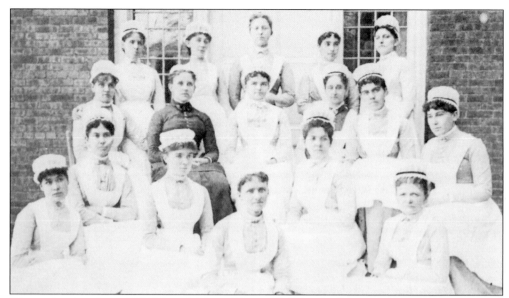

The graduation class of 1886 from McLean Hospital's School of Nursing was the first of its kind in the world, where nurses were trained to serve patients in a mental asylum. (Courtesy of the Somerville Public Library.)

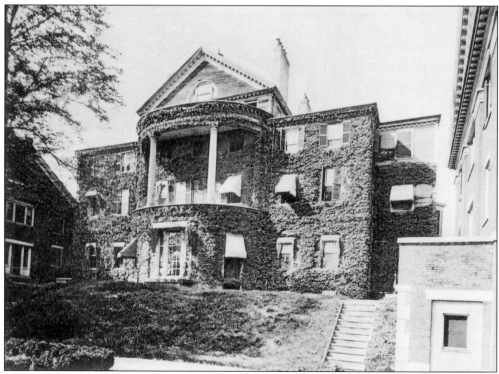

By the 1890s the McLean Asylum had copious amounts of ivy covering the brick walls of the old Barrell Mansion. Though hemmed in by the flanking wings, the Bulfinch-designed mansion still had retained its character.

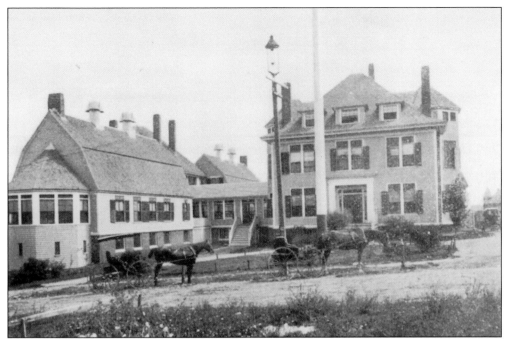

The Somerville Hospital was a small institution catering to the medical needs of the residents of Somerville after it was founded in 1891. Two horse-drawn carriages wait at the curb outside the Colonial Revival hospital about 1893. The large gambrel-roofed building on the left had wards for patients.

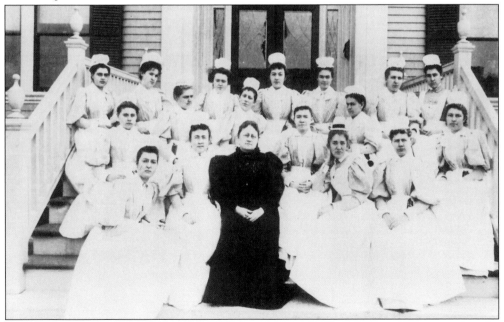

The Somerville Hospital School of Nursing was founded in 1893, just two years after the founding of the hospital. Members of the first graduating class pose for their class portrait in 1895 on the front steps of the hospital with an instructor in the center of the first row. (Courtesy of the Somerville Public Library.)

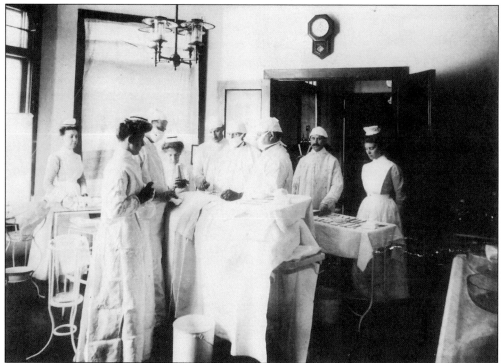

The operating room at the Somerville Hospital might seem somewhat primitive today, but when it was photographed about 1905 it was the epitome of service. Notice the nurse holding the anesthesia cone over the patient's face and the surgical instruments on the tray on the right. (Courtesy of the Somerville Public Library.)

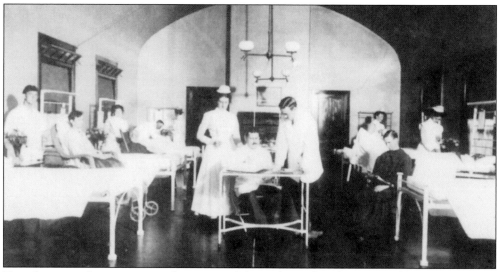

Two doctors and a nurse are in the center of the male ward at the Somerville Hospital in the early years of the twentieth century. The city of Somerville secured a horse-drawn emergency police ambulance in 1894 to rush residents in need of medical assistance to the hospital. (Courtesy of the Somerville Public Library.)

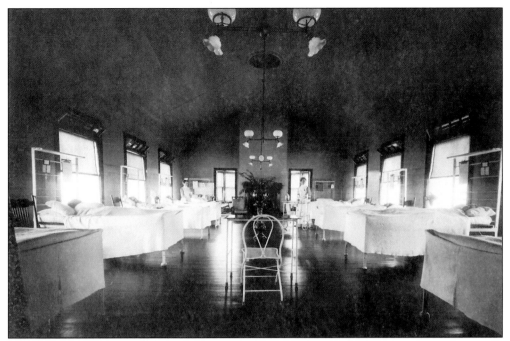

The male ward, seen in 1903, had patients in clean, comfortable beds and attention from well-trained nurses. (Courtesy of the Somerville Public Library.)

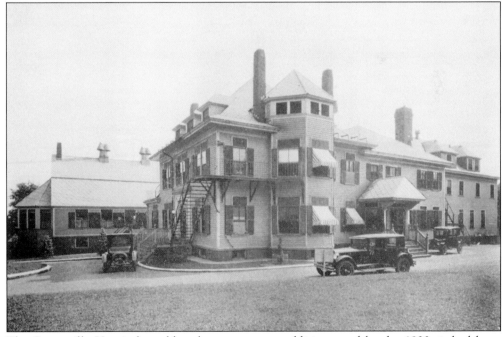

The Somerville Hospital would undergo numerous additions, and by the 1920s it had been greatly enlarged from the Colonial Revival hospital built in 1891. A new building would be added on the right in 1931. Note the automobiles parked on the driveway.

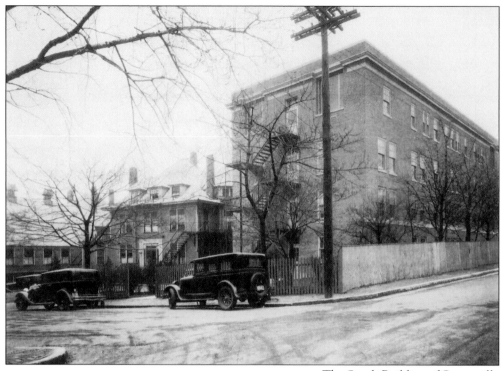

The South Building of Somerville Hospital was built in 1931 on Crocker Street, adjacent to the original building. (Courtesy of the Somerville Public Library.)

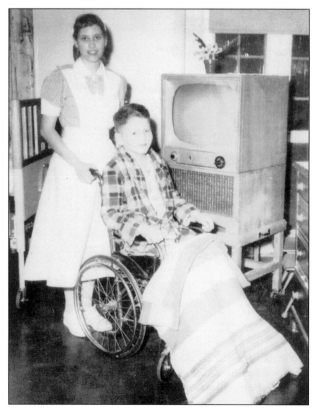

A young patient at the Somerville Hospital in 1957 is wheeled to the television room by a nurse in a "Tiny Tot" wheelchair, which was donated by the Kiwani-Annes, the woman's auxiliary of the Somerville Kiwanis Club. (Courtesy of the Somerville Public Library.)

Three nurses exit the Somerville Hospital in 1956, the 65th anniversary of the founding of the hospital. (Courtesy of the Somerville Public Library.)

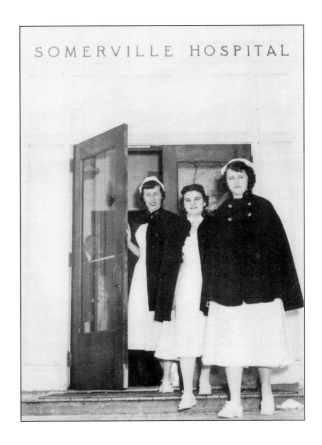

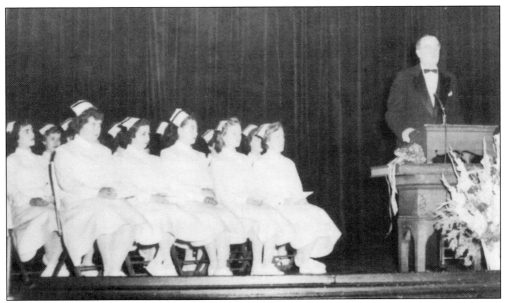

Members of the Somerville Hospital School of Nursing, class of 1956, listen to a speech during graduation exercises. (Courtesy of the Somerville Public Library.)

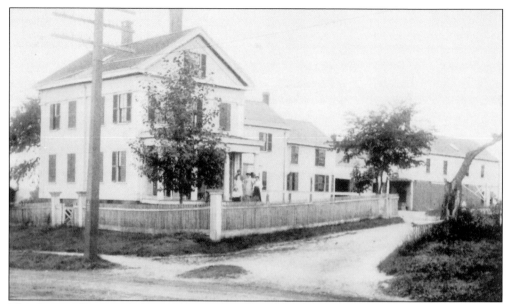

The Somerville City Infirmary was on Broadway in this Greek Revival house. A group of nurses stand on the steps leading to the infirmary, which provided medical care for those who needed it.

Residents of the Somerville Home for the Aged pose in front of the entrance on Summer Street in 1961. Incorporated in 1898, the home was first opened in 1900 on Grand View Avenue with a matron and two residents. The home on Summer Street was built in 1927 with accommodations for fifty-eight residents. (Courtesy of the Somerville Public Library.)

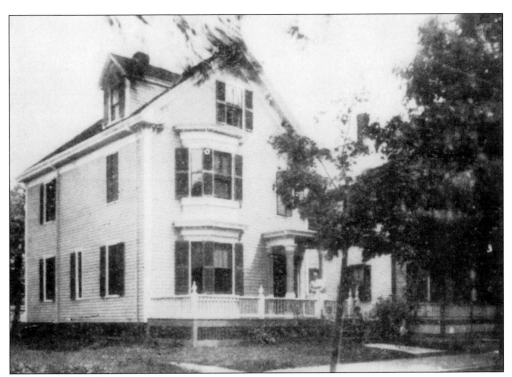

The Children's Home was on Day Street in West Somerville.

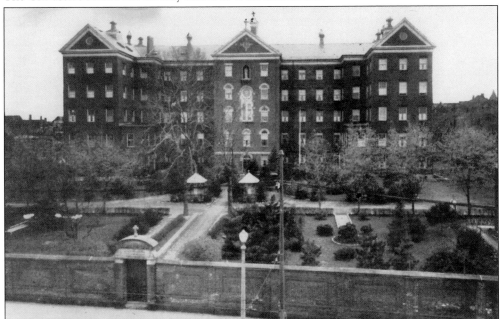

The Home for the Aged Poor was founded in 1880 and maintained by the Little Sisters of the Poor at 186 Highland Avenue. Founded in 1850 by Jeanne Jugan in France, the Little Sisters of the Poor opened a home in Somerville for the elderly who could not afford to care for themselves and where they might "find there a haven from life's storms." (Courtesy of the Somerville Public Library.)

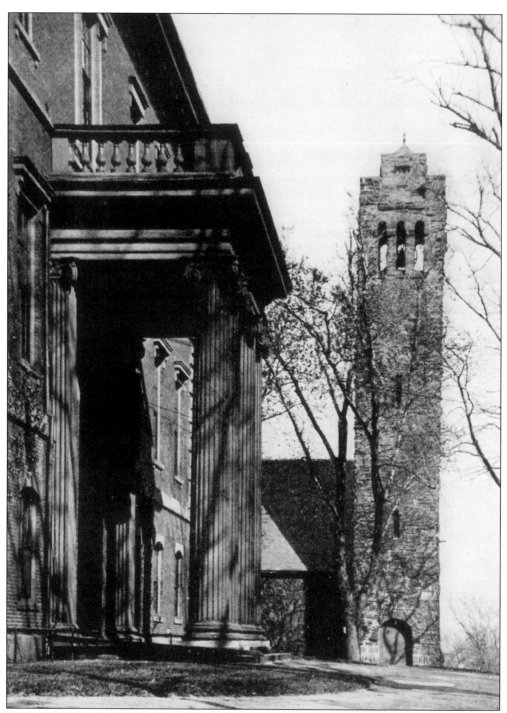

Ballou Hall (on the left) and Goddard Chapel create an impressive vista on the campus of Tufts College in this photograph from 1942. Goddard Chapel is a Romanesque Revival chapel with a Lombardic tower that was built in 1883 through the generosity of Mary T. Goddard, widow of Thomas A. Goddard, a wealthy merchant and "one of the grandest laymen that the Universalist Church has ever produced."

Nine
TUFTS COLLEGE

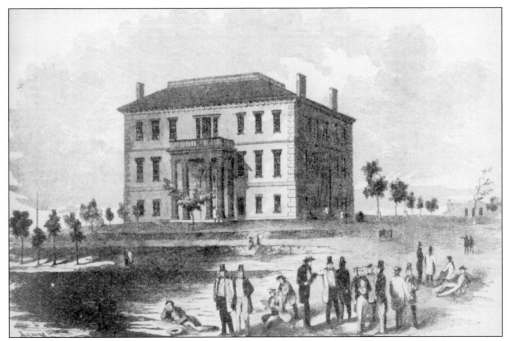

Ballou Hall was sketched at the time of the opening of Tufts College in 1855. Located on College Hill, formerly known as Walnut Tree Hill, 20 acres of land were donated by Charles Tufts, a local land owner who said of the hill, "I will put a light on it." The "light" was to be the beacon of liberal education offered by Tufts College, which was founded in 1852 and named in his honor. Tufts later increased the gift to 100 acres and a further 20 acres were donated to the college by Timothy Cotting of Medford, Massachusetts.

Reverend Hosea Ballou II was the first president of Tufts College. Founded as the first Universalist college in the world, the charter for Tufts College was signed in 1852 by Governor George S. Boutwell. President Ballou prescribed the course offered, which was that leading to an A.B., and the college opened in 1855 with five professors and thirty students. However, though an Universalist college, no instructor was required to be a member of that particular religion.

Ballou Hall was named in honor of Hosea Ballou. It was designed by Samuel J.F. Bryant and was the first building of Tufts College.

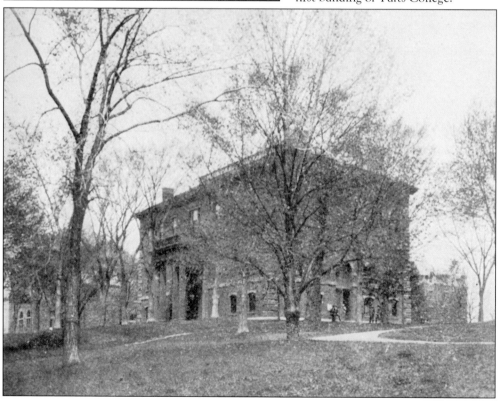

Reverend Alonzo A. Miner, D.D., LL.D., was elected in 1862 as the second president of Tufts College. During his presidency, new courses were established which led to the conferring of new degrees, such as a course on civil engineering in 1869. Resigning in 1874 to pursue ministerial work in Boston, Miner was succeeded by Reverend Elmer Hewitt Capen, a member of the Tufts Class of 1860.

Miner and Paige Halls were built through a generous contribution of Reverend Alonzo Miner for a building "to be used exclusively by the theological department," and Paige Hall was built through subscriptions for a dormitory for the theological students. Miner Hall, now referred to as Divinity Hall, was designed by local Somerville architect George F. Loring.

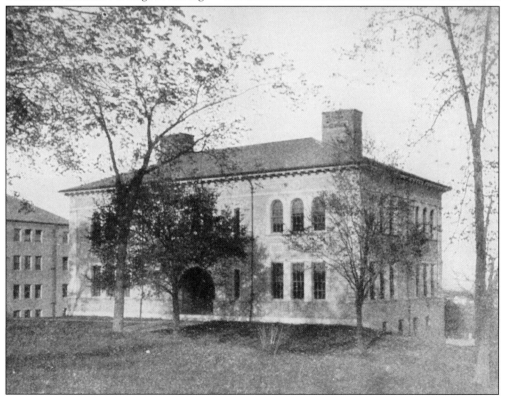

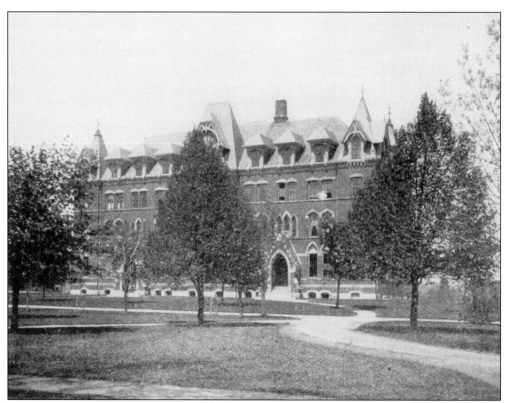

West Hall was adjacent to the reservoir that surmounted College Hill. A Ruskinian Gothic building, it had a fanciful roof with dormers and modified mansard roofs.

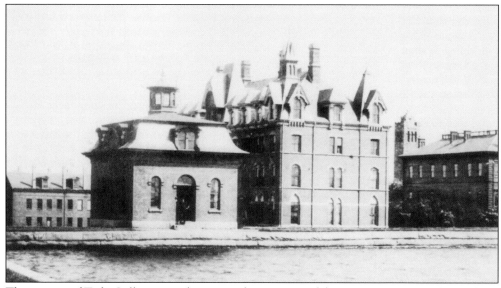

The campus of Tufts College was adjacent to the reservoir of the Mystic Water Works. Built on College Hill (originally known as Walnut Tree Hill) in 1862 by the city of Charlestown, it was a reservoir for water storage. Built of brick and stone, with a depth of 20 feet, it provided water during any unforeseen drought.

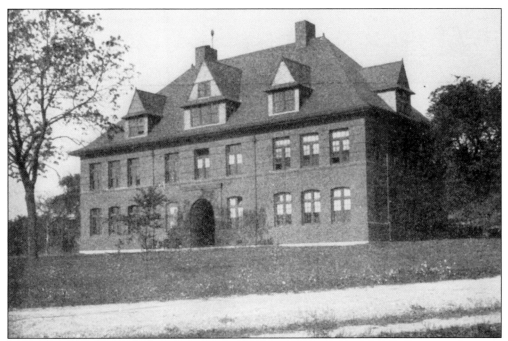

The Bromfield-Pearson Building was named for Mr. Bromfield and F.S. Pearson, the most eminent consulting engineer at the turn of the century and a member of the Tufts Class of 1883. The building was the gift of the late Henry B. Pearson for technical training in drawing, pattern making, machine, and forge work.

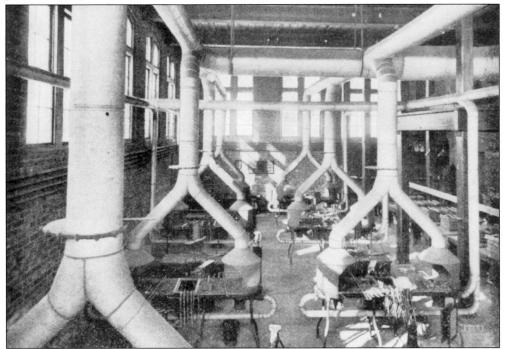

The forge shop in the Bromfield-Pearson Building provided a working place where students could experiment in machine and forge work.

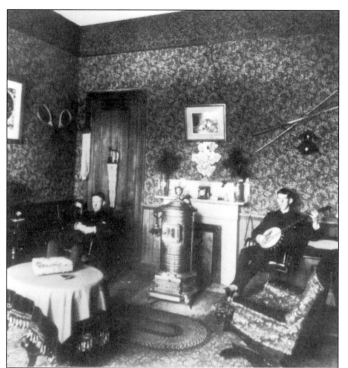

Students at Tufts College in 1886 relax in their dormitory room, complete with a pot-bellied stove! Notice the crossed tennis rackets on the left and the pool cues on the right. All the comforts of home while away at college! (Tufts University Archives.)

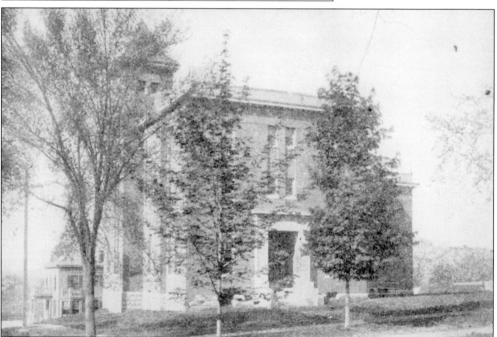

Metcalf Hall and Start House, on Professors' Row, can be seen just beyond a stand of young trees. Metcalf Hall was named for Robert Metcalf, a superintendent of the Boston Public Schools; in combination with Start House, which was the dormitories for the female students (who were admitted to Tufts in 1892 in great opposition to the entire student body and a majority of the alumni), it created the beginnings of the campus dormitories.

Ten

THE FELLSWAY
DRIVING CLUB

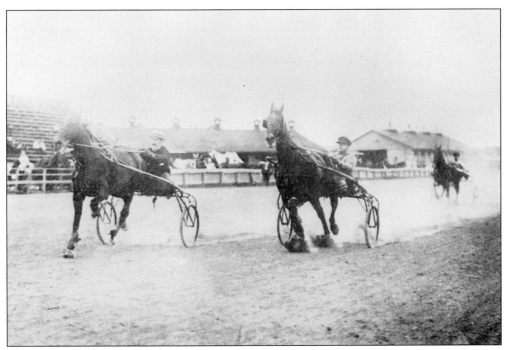

Two drivers race their horses at Combination Park in Medford, Massachusetts, to a hot finish. The dust was raised in this race between the Fellsway Driving Club of Somerville and the Metropolitan Driving Club. The Fellsway Driving Club of Somerville, Massachusetts, was formed on March 7, 1908, by James Brooks, Frank Morrison, George Davis, Harry Litchfield, F.S. McKown, Daniel Paine, George Davis, Fred Brown, Albion Towle, William Patten, George Coyle, G.M. Welch, and William Garland.

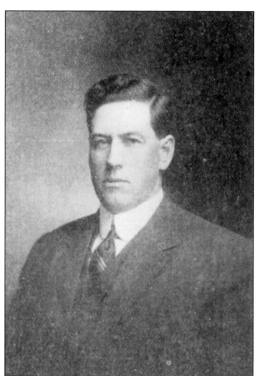

James I. Brooks was president of the Fellsway Driving Club of Somerville from 1908 to 1909 and again in 1911. A buyer and seller of horses in Somerville, he "left no stone unturned in bettering the condition of the organization, both in securing members and financially." Brooks lived at 30 Sewell Street in Somerville.

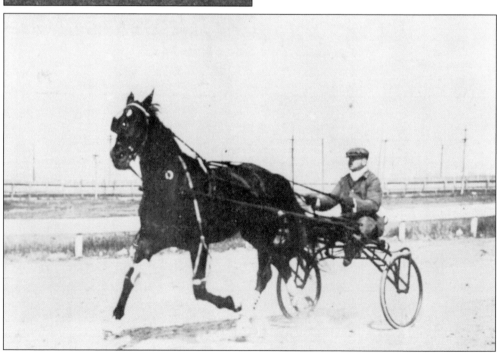

C.E. Twombly races Doctor, who was "perhaps the best known matinee trotter in Greater Boston" at the turn of the century. Twombly raced Doctor for nine consecutive seasons and was a constant prize winner. Doctor's record for a half mile is 1:07.5, made at the Charles River Speedway, and his winning heats at Combination Park in Medford were in 1:10 and 1:12.

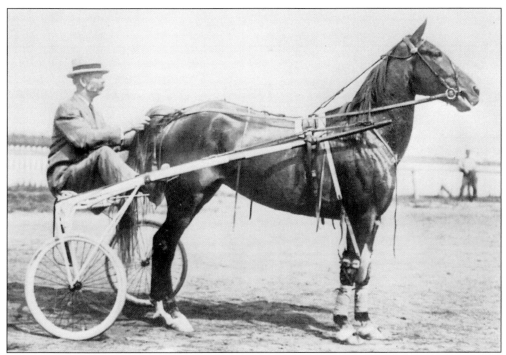

George A. Law sits on his matinee cart with Fanny M., his race horse who was "always in the thick of the racing battle."

George A. Law was president of the Fellsway Driving Club of Somerville from 1912 to 1914. A resident of Arlington, Massachusetts, he operated a hack, boarding, and livery business since 1888, offering a well-run stable for his fellow "horse-flesh" enthusiasts.

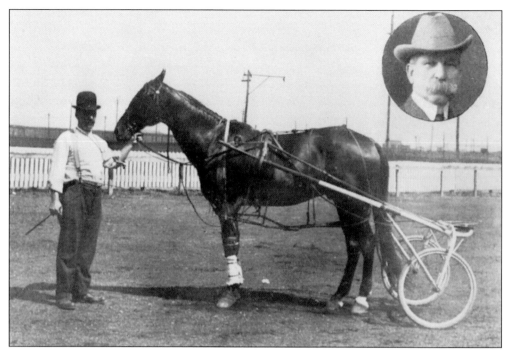

George L. Davis holds Argot Lad's halter at a Fellsway Driving Club meet; Davis' photograph is inset on the right. The first quarters of the Fellsway Driving Club were at 2 1/2 Franklin Street in Somerville, which was called the Fellsway Clubhouse.

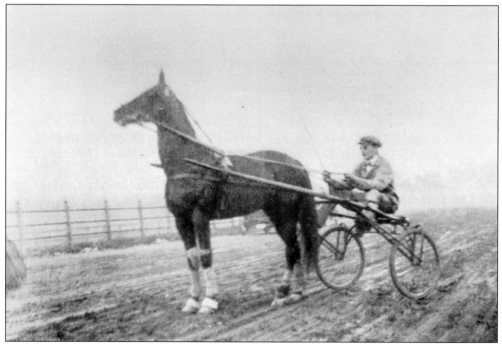

A.I. Nelson sits on his matinee cart with The Montana, "one of the greatest half-mile track campaigners." Nelson, who was born in Sweden, ran a provision store in Davis Square and lived at 890 Broadway in Somerville.

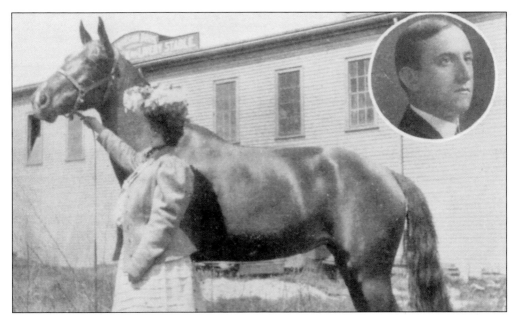

Mrs. Ernest C. Smith holds the halter of Lady Hilton outside the livery stable of the Jameson Brothers. Lady Hilton was the winner of the Point Cup of the Metropolitan Club in 1904. Ernest C. Smith, whose photograph is inset on the right, was a wholesale dealer in butter, cheese, eggs, and poultry in Boston and lived at 22 Hudson Street in Somerville.

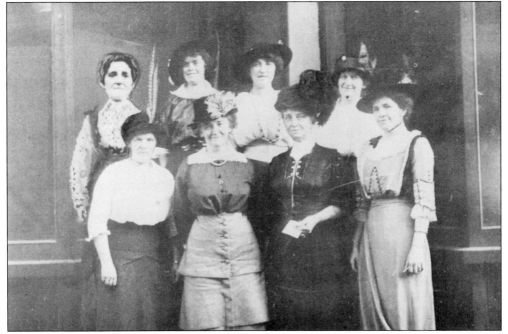

The Ladies' Auxiliary of the Fellsway Driving Club was organized in 1909 by the wives of members to raise funds that would benefit the club. The members included the following, from left to right: (front row) Mrs. A.J. Carpenter, secretary; Mrs. C.W. Thyng, vice president; Mrs. Agnes M. Cornwell, president, and Mrs. Knapp Forshner, treasurer; (back row) Mrs. Frank E. Morrison; Mrs. L.H. Phelps; Mrs. Orin E. Linscott; and Mrs. A.B. Pritchard.

ACKNOWLEDGMENTS

I would like to thank the following for their assistance in researching this book. In many instances, the following individuals have loaned photographs, stereoviews, and books on the history and development of Somerville and I appreciate their continued support and interest:

Daniel J. Ahlin; Paul and Helen Graham Buchanan; Jamie Carter, my patient editor; Frank Cheney; Dexter; Anthony V. Fedele (retired) headmaster of the Somerville High School 1988–1997; Somerville Hospital; Helen Hannon; Edward W. Gordon; James Z. Kyprianos; Stephen and Susan Paine; David Rooney; Anthony and Mary Mitchell Sammarco; Rosemary Sammarco; William Varrell; and Paul De Angelis, director of the Somerville Public Library, and the members of the library staff.

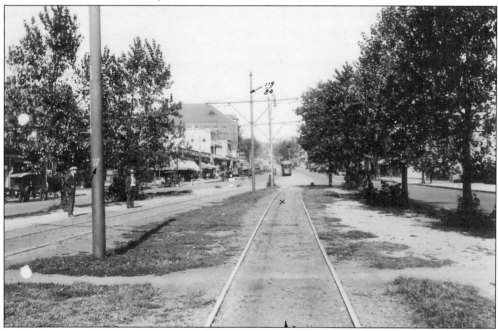

Looking west in 1925 on Broadway, toward Winter Hill, the streetcar tracks seem to stretch for miles. Two gentlemen stand on the left awaiting the streetcar that is approaching the stop. Broadway (now Foss) Park is on the right and storefronts, complete with summer awnings, can be seen on the left. (Courtesy of Frank Cheney.)